Egyptian Painting and Drawing
in the British Museum

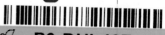
P9-DHI-407

BERKELEY SCHOOL LIBRARY
WHITE PLAINS, NEW YORK

T.G.H. JAMES

HARVARD UNIVERSITY PRESS

Cambridge, Massachusetts

1986

7752

Copyright © 1985 by the Trustees of the British Museum
ISBN 0–674–24153–3
Library of Congress Catalog Card Number
85–081186

Designed and produced by Roger Davies
Printed in Italy

**THE TRUSTEES OF THE
BRITISH MUSEUM
acknowledge with
gratitude the generosity
of
THE HENRY MOORE
FOUNDATION
for the grant which made
possible the publication
of this book.**

Front cover Dancing girls at an entertainment. Detail of fig.27.

Inside front cover Landscape in Middle Egypt.

Title page The retriever cat. Detail of fig. 25.

Contents pages Part of the Satirical Papyrus. Animals engage in human activities.

Inside back cover Attendants of Queen Hatshepsut with axes, fans and divine standards run in procession. Painted relief from her temple at Deir el-Bahri.

Back cover Sakhmet, the lioness-headed deity, one of the divine family of Memphis. From the Great Harris Papyrus.

Contents

1 **Introduction** page 5

2 **The Egyptian artist, his materials and his techniques** 8

3 **Mural painting** 19

4 **Line drawing** 40

5 **Illuminated papyri** 51

6 **Other forms of painting** 65

The Dynasties of Egypt 71

Short Bibliography 71

Index to the Collection numbers 71

Index 72

Photo Acknowledgments 72

3

1 Introduction

Egypt is a land in which colour is of the greatest importance. Colour is everywhere, and particularly when the sun shines. The bright sun and deep blue sky form the setting for a country where the predominant colours are the green of the cultivated areas and the dun of the desert. But the subtleties of colour which enrich the ever-changing landscapes as one moves from north to south contain within their infinite gradations the sources for and clues to the palette employed by the ancient Egyptians.

Not all ancient Egyptian painting is worthy of serious consideration; the application of colour to enhance something drab was instinctive for a relatively simple people wishing to enliven not only the objects of daily life but even the objects which might accompany a man to his after-life in the tomb. In this respect the ancient Egyptians were no different from peoples of other cultures; but in expressing their particular love of colour the Egyptians went far beyond the garish and insensitive squandering of colour found elsewhere in antiquity and in more recent primitive societies.

To purge one's attitudes from preconditioned judgements is exceptionally difficult even in these days of artistic anarchy in which the use of colour by particular artists can only with temerity be described as 'garish' or 'insensitive'. Nevertheless, within the whole corpus of surviving Egyptian painting the modern student, acquainted with the conventions of Egyptian art, can discern what may be

1 An Upper Egyptian landscape: the river, the desert and the cultivation.

2 Painted limestone relief from the temple of Deir el-Bahri. The god Amon-Re receives a huge presentation of offerings.

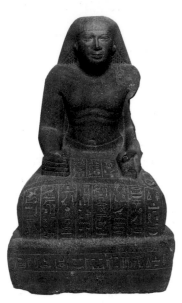

3 Quartzite statue of the high official Pes-shu-per shown as a scribe. He holds an open papyrus roll on his lap, and has two ink palettes, one on his left shoulder and the other on his left knee. Height 53 cm (no.1514).

termed outstanding, good, indifferent and bad examples.

If the intention of the study of an art in a culture like that of ancient Egypt is to identify what was thought in antiquity to be the best then the conventions and standards of antiquity need to take priority over those employed today for the judging of modern art. Yet the very wide range of styles which exist and are appreciated by connoisseurs and critics of modern art, should enable today's student of ancient art to approach the products of Egyptian artists with greater sympathy than at any time since the early nineteenth century when these products first become known in modern times.

It may be taken as reasonably certain that in any given period during the three thousand years of Pharaonic rule, the work executed for the king was carried out by what were thought to be the best artist-craftsmen of the time. They were, for the most part, unnamed members of teams whose duties lay in the preparation of the royal tomb, the construction and decoration of temples and the embellishment of royal dwellings. Only in the case of the last, generally speaking, was pure painting employed, for the domestic buildings of Egyptian kings, like those of their subjects, were built of unbaked mud-brick, the interior walls of which were plastered and decorated with paintings executed in a tempera technique. Royal tombs and temples, buildings for eternity, were commonly decorated in relief, the carved scenes and inscriptions being painted after the completion of the carving.

There can be little doubt that painted carved relief was the ideal form of decoration, preferred by the ancient Egyptians whether royal or not. For various reasons, however, carved relief could not always be provided: the quality and texture of the stone of the walls of an excavated tomb might not allow carving; the status of the owner of a tomb might not permit him to indulge in such extravagant display; frequently the tomb might be in such an incomplete state at the death of the intended owner that there was no time to carry through a full scheme of carved and painted relief. When relief was not possible, then drawing and painting had to suffice, and some of the very finest examples of drawing and painting surviving from antiquity are due to adventitious circumstances. The painter who is not controlled and, whose brush is not, in a sense, circumscribed, by the sharp outline of relief, can work with greater freedom; the artist who executed the preliminary drawings, known as the outline scribe, aware that his outlines would be used ultimately to guide the relief carver, could still wield his brush with supreme confidence. Happily, much in the way of straight painting and of preliminary draughtsmanship has survived, revealing with striking clarity the skills and aesthetic sensitivity of artists who worked to achieve results which would scarcely ever be seen (tomb painting) or which might disappear beneath the strokes of the carver's chisel (preliminary drawings).

There was no cult of the artist in ancient Egypt, as far as can be determined. Certain artists are known by name because they were the owners of identifiable tombs; a few others proclaimed their profession for particular reasons of self-promotion, like the sculptor Bak who claimed that he had been instructed in his skills by King Akhenaten. Generally speaking, artists were part of the community of craftsmen who served the highest in the land, practising their craft to the best of their ability; and by any standards their abilities were remarkable. In determining their standards, draughtsmanship and technical excellence play significant roles. The best Egyptian artists were technically supremely competent; their training was strict and based on conventions which provided the good student with a

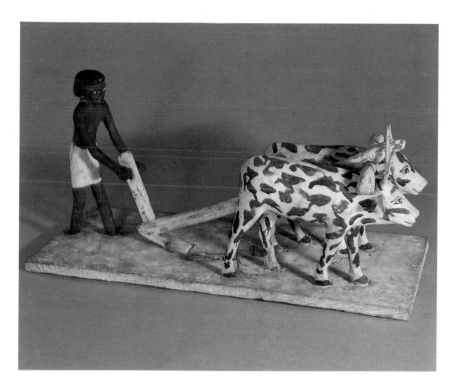

4 Painted wooden tomb model of the Middle Kingdom, showing a peasant ploughing with a pair of oxen. Length 43 cm (no. 52947).

framework of technique applicable to almost all subjects. The occasional departure from convention might land the artist in considerable difficulty, as we shall see (p. 29, *fig.* 27). Nevertheless, within the strict limits of convention, and undoubtedly supported by its comprehensive range, the artist was still able to display qualities of genius, certainly appreciated today, and, it may be hoped, by his masters in antiquity.

From the collections in the Department of Egyptian Antiquities in the British Museum it is possible to illustrate all the main categories of drawing and painting which represent the practice of the graphic arts in Egyptian antiquity. Of paintings in the strictest sense there are two fine fragments from the *mastaba* – chapel of Nefermaat and Itet at Maidum, rare examples of the painter's art of the Fourth Dynasty (*c.*2580, BC); and several series of paintings from Theban tombs of the New Kingdom, including those from the tomb of an official probably called Nebamun. There are, within the Museum's outstanding papyrus collection, many fine illustrated religious papyri, the ancient world's equivalent of the illuminated manuscripts of Medieval Europe; coloured vignettes in the Papyrus of Ani (no. 10470) are miniature paintings which rival the best of the murals in Theban tombs of the same period. The simple ink illustrations of the papyrus of Nesitanebtashru (no. 10554) and Ankhwahibre (no. 10558), demonstrate a command of line which would not have disappointed the best of European drawing masters. Coffins of the Middle Kingdom carry paintings of funerary offerings composed into groups designed with restrained economy; coffins of the late New Kingdom, are, on the other hand, decorated with a wealth of detail which needs to be carefully analysed to extract its iconographic variety.

Colour can be seen in all the galleries containing Egyptian antiquities. Many Egyptian sculptures, thanks to the conditions in which they have been preserved since ancient times, retain substantial traces of paint, while many funerary inscriptions are coloured so brightly that they may well be thought to have been touched up in modern times. By describing representative examples of what may be seen in the galleries, supplemented by some objects not at present on exhibition, a fair idea of the scope and splendour of the ancient Egyptian artist's abilities and achievements may be gained. In addition, some reference will be made to standing monuments in Egypt, and a few illustrations will also be drawn from the masterly facsimiles of Egyptian painting, made by Nina de Garis Davies. She was both the most accurate and most sensitive of copyists, and examples of her art provide fine material to supplement the actual ancient paintings in the collections.

2
The Egyptian artist, his materials and his techniques

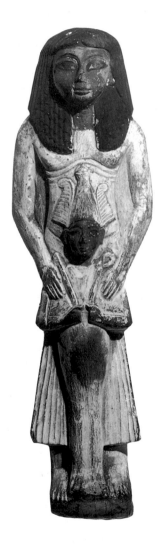

5 Painted limestone figure of the outline scribe Nebre. He is shown holding an effigy of the god Osiris. Height 25 cm (no. 2292).

The anonymity of the Egyptian artist has already been mentioned; this anonymity is partly a matter of identification, because many artists are named in texts, especially of the New Kingdom. Unfortunately they are so named that they may be identified as individuals and not as the artists who carved or painted particular works of art. They worked as professional craftsmen, usually as members of teams.

The extraordinary thing about painting in ancient Egypt is that there was no distinct word, as far as is known, for 'painter' or 'artist'. The term used to describe the craftsman who marked out the preliminary drawings on the wall was 'outline scribe', and the important element here is 'scribe'. The scribe was essentially the man who could write or perhaps more specifically, who could use a brush (his basic piece of equipment) to write or to draw. The word 'scribe' was written with a hieroglyphic sign which incorporated the working tools of the man who wrote (): a tall, hollow, cylindrical container to hold the brushes, a small bag of ink-powder, and a wooden palette with two depressions to hold black and red ink or paint. Scribes were taught to write and to read what was written, both in the hieroglyphic script and in the scripts used for texts written on papyrus. The word 'to write' also incorporated the same sign used for the word 'scribe'.

Scribes, however, were taught much more than the ancient equivalent of shorthand and typing. Some scribes were selected, partly by the operation of well-established nepotism, and partly (it must be hoped) by ability, to be trained further in administration, ultimately to become the mandarins of the Egyptian bureaucracy. Others were to become 'outline scribes'; those whose talents as artists eventually flowered, were employed to carry out the innumerable duties for which painting was required.

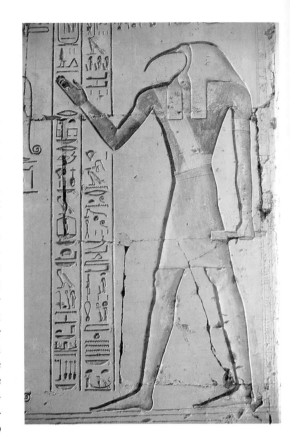

Strictly speaking, the 'outline scribe' was precisely the man who drew the outline designs. A papyrus in the Egyptian Museum in Turin contains the plans of the tomb of King Ramesses IV of the Twentieth Dynasty (c.1160 BC) and a note, written in the hieratic (cursive) script, about the fourth corridor of the tomb, describes it as 'drawn with outlines, carved with the chisel, filled in with paint, and finished'. These are the processes by which a plain wall was converted into a series of painted reliefs. The words 'drawn with outlines' are made up of the very word-roots used in 'outline scribe'; 'drawn' uses the same hieroglyph employed for 'scribe' and 'write'.

In the preparation of carved relief, the functions of the 'outline scribe' and the 'wiel-

6 The god Thoth, ibis-headed scribe of the gods. In this painted limestone relief from the temple of Ramesses II at Abydos, he is shown holding a scribal palette.

der of the chisel' (i.e. sculptor) are clear. So too is the function of the craftsman who finally completed the work by adding paint. There is some evidence to suggest that paint was applied also by men described as 'outline scribes'. But the application of paint on carved relief was not just a matter of filling in areas, as in a child's colouring book. The best painted reliefs have a wealth of detail added in paint, and the careful application of any paint was in all circumstances highly desirable, so that the paint enhanced the carving and did not overwhelm its subtleties. In the case of straight, flat, murals, where no relief was present, the whole quality of a painting, in outline, colour and detail, was dependent on the co-operative effort of teams of craftsmen, all of whom wielded brushes, and all, perhaps, known as 'outline scribes'.

There was, no doubt, a hierarchy within a team of painters working on the walls of a tomb-chapel of a high official in the Theban Necropolis during the Eighteenth Dynasty. Yet how difficult it would be to decide which stages in the completion of a scene were in the hands of the best artists! The stages themselves will be described later on; what needs to be suggested here is that the best artists might intervene in the work at any point, for they would be the masters in charge, responsible for the work and inspired by pride in their craft to ensure that their team produced the best possible result.

The ordinary scribe, the backbone of administration, was frequently shown at work in Egyptian tomb and temple scenes. The artist, on the other hand, is scarcely ever depicted, and there is hardly a shred of evidence to show how he worked. The fine carved scenes which fill the great walls of temples and equally the more intimate, smaller-scale painted decorations of private tombs, could not have been sketched directly on to walls without carefully prepared preliminary drawings or cartoons.

None has ever been found. The same is the case for the long and elaborate inscriptions which accompany the scenes. Pattern-books, or their ancient equivalent, have been suggested, but the lack of frequent and precise repetition in the content and detail of scenes where this repetition of themes occurs argues against the usage of such.

Scribal training on the side of draughtsmanship must have involved careful schooling in the wide repertoire of scenes needed in different kinds of buildings. This repertoire formed undoubtedly the basic fund of ideas on which the artist could draw when preparing the scheme of decoration for a tomb. But there are few tombs which lack original material among the commonplace and it must be assumed that the artist in charge of a tomb's decoration was able to use his invention and initiative, within the brief he must have discussed with the prospective tomb-owner or his agent. The scheme eventually was surely presented for inspection, outlined on papyrus, limestone flakes, or, most probably, wooden boards.

In two tomb chapels of the Sixth Dynasty at Saqqara, the tomb owners are shown seated before what can only be described as easels, completing a design. The one illustrated here (fig. 7), in the tomb of the vizir Khentika shows him, called by his familiar name Ikhekhi, applying a brush to a board on which are depicted three squatting figures, two female and one male. These 'creatures' are named after the three seasons of the Egyptian year (inundation, coming-forth of the land, and drought). What concerns us here are the details of what Ikhekhi is doing. In his left hand is a shell-shaped dish containing, presumably, his paint; a jar on a tall stand, and a second, unsupported, jar may also have contained paints. The board on which he works seems unsupported, but the designer of the scene may for some reason have deliberately omitted the easel-stand found in the com-

panion representation of the scene in the near-by tomb of Mereruka. The stepped detail at the bottom right-hand corner of the board may represent a ratchet which would have allowed the board to be set at varying angles for the convenience of the artist. Here then is, it seems, an artist at work, even if he is in fact a vizir, the highest official in the land. To his aid, at the bottom left, run three assistants, the first two carrying scribal equipment.

In this scene of painting, or perhaps drawing, the ideas of scribal activity are closely interwoven with those of artistic activity – they were not distinct to the ancient Egyptian. This lack of distinction was due not only to the close relationship between scribe and artist through basic training, but also to the fact that the essential tool of scribe and artist was the brush. Throughout the Pharaonic Period scribes wrote with a fine rush, the *Juncus maritimus*, which is found abundantly in Egypt. This rush could be trimmed to form a chisel-like tip chewed to make a fine brush capable of producing thin and thick lines. Very many examples of such 'pens' have been found as part of scribal equipment, often inserted into the special slot in scribal palettes (*fig.* 8). In using this brush the scribe held his hand away from the surface on which he was writing, so that his action was much more that of a painter than a clerk. This very same kind of rush brush was equally used by the scribe/artist who drew the illustrations in illuminated papyri. It may even have been the case that the same person both wrote the texts of such papyri and drew the vignettes, exercising far greater control over the lay-out of the papyrus than two or more persons would do. Unfortunately there is no good evidence to support this view.

Brushes for less fine work were made of fibrous materials bound together in varying thicknesses. Some brushes consisted of lengths of palm-rib beaten out at one end to produce

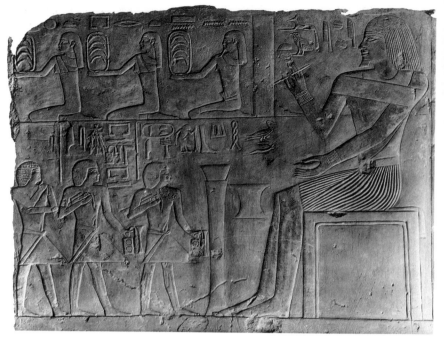

something like a very stiff shaving brush. Such brushes sound impossible to use, and on physical inspection do not look any more suitable for elaborate work. Examples in the Museum, some clogged still with paint, prove fairly conclusively that they were used as paint-brushes (e.g. no. 45217). The best evidence, however, was provided by the discovery in a Theban tomb of the Eighteenth Dynasty of a bundle of painter's equipment tied up with a length of string (*fig.* 9). Norman de Garis Davies, the discoverer, describes the brushes as bruised twigs, pieces of palm-rib and fibrous wood, and he rightly identifies the string as the cord used by draughtsmen to mark out a wall into squares. He also describes a broken piece of pottery filled with blue paint found near the bundle of brushes, clearly the artist's paint-pot. The casual use of suitably shaped pot sherds for this kind of purpose is completely in accord with what is known of the 'make-do-and-mend' attitude of the an-

7 The vizir Khentika paints figures of the three seasons. The ovals held by the figures contain crescent moons representing the months.

8 *above right.* Wooden scribal palette with a slot containing rush brushes, and two depressions for black and red colour. The inscription gives the name of King Amosis of the Eighteenth Dynasty (*c.* 1570–1546 BC). Length 29 cm (no. 12784).

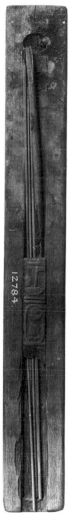

cient craftsman towards the tools and methods of his trade. The mastering of the use of what seem to be inadequate tools can be understood and accepted, but one may yet wonder how the artist succeeded in keeping his crude brushes supple.

At first sight the brilliant colours which survive in so much ancient Egyptian painting can scarcely be accepted as ancient. They appear to be as fresh as on the day they were applied. The pigments used were almost all manufactured from naturally occurring mineral substances the colours of which are not subject to change or fading. Many specimens of colours have been examined, and a very clear idea of their composition now exists. Generally speaking, naturally occurring raw material was finely ground and then made into cakes by the addition of some binding agent, perhaps a vegetable gum. A further agent, or medium, was used for the application of the paint; it is thought to have been one of three possibilities: size (a gelatinous material), gum or egg. Egyptian painting is not oil based, nor is it fresco (a technique that requires the application of the paint on wet plaster); it is tempera, and any of the three possible mediums would have suited. Unfortunately no modern scientific techniques have yet been able to isolate what was used.

The principal colours were made from the following substances:–

White: calcium carbonate (chalk) or calcium sulphate (gypsum).

Black: carbon in one of several possible forms, the most common being soot scraped from the undersides of cooking-pots. Lamp black, deposited by the flames of oil lamps, and ground-up charcoal and bone-black (from burnt bones), were also used.

Red: the naturally occurring oxides of iron, principally red iron oxides and red ochre.

Blue: from at least the Old Kingdom a manufactured pigment called blue frit or, more commonly, 'Egyptian blue', made from a com-

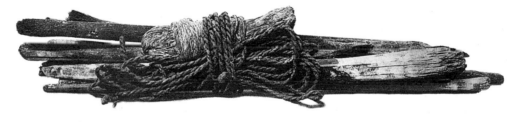

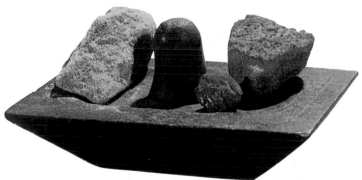

9 A painter's equipment found in the tomb of Mentuhirkhopshef at Thebes. The very coarse brushes are still clogged with paint, and the string wound round the bundle is stained with red colour. The latter was used to mark out the grid on a prepared surface.

10 Basalt palette and grinder used for the preparation of the raw materials of paint here represented by three pieces of coloured frit. Found in Thebes and probably of New Kingdom date, 1450–1250 BC. Length of palette 12 cm (no.5547).

pound of silica, copper and calcium, usually in the form of quartz, ground malachite, calcium carbonate and natron.

Green: the ultimate source of this colour was copper. Green pigment was derived either from powdered malachite, a naturally occurring copper ore, or from a manufactured green frit similar to that used for blue.

Yellow: mainly yellow ochre, but also, from the late Eighteenth Dynasty (*c.* 1400 BC), orpiment, a naturally occurring sulphide of arsenic.

The materials used for these principal colours were all readily available in Egypt, with the exception of orpiment. It has been suggested that orpiment was imported from Persia, an idea that is by no means outlandish when it is realised that probably all the lapis-lazuli used in Egypt and elsewhere in antiquity came from Afghanistan.

The palette available to the Egyptian artist was in no way restricted to these principal colours. We shall see later how skilful the artist was in mixing the primaries to obtain secondary colours: grey (black and white), pink (red and white), brown (red and black), and other combinations for different shades. Other colours, achieved by the use of variations of mix and additions of unusual materials, were not uncommon. While the ancient Egyptian palette may truly be described as limited, the results achieved with it were not. The visual evidence of the colours found on actual paintings again testifies to the genius of the ancient artist/craftsman who was not seriously inhibited by the small available range of primary colours, any more than he was by the crude nature of his brushes.

There has been some dispute over the medium used for the application of paint. It is certain that the technique was neither that of the fresco-painter, nor that of the painter in oils. The former applies his colour to wet plaster, while the latter uses an oil (turpentine or linseed) as the vehicle. The Egyptian technique was that of tempera or gouache. Colours were mixed with a vehicle or medium which would help the pigment to 'hold' and enable it to be applied with the assistance of water. Artists since the Renaissance have used gums of various kinds and egg as this vehicle. Egg is unlikely to have been used in Egypt because of the dryness of the climate and the heat. Gum or size certainly may have been used, perhaps both; of the various natural gums available, that from the acacia tree is the one most probably employed; size, a gelatinous material, could easily have been prepared from bones, skin, cartilage, and other animal waste.

Although paint was sometimes applied directly on stone or even on mud plaster, it was more usual for the artist to prepare the surface by applying a thin coat of whiting or a coloured wash. To protect finished paintings, and perhaps to enhance the brilliance of the colours, varnishes (natural resins) were sometimes used, more commonly on painted wooden objects, but also occasionally on tomb walls. This practice, however, was by no means regular, and even in tombs where varnished surfaces can be identified, the varnish seems not to have been applied universally. These varnishes have over the years become rather yellow, changing in tone the underlying colours. Traces of beeswax, used apparently for the same purpose, have also been identified in some tombs.

It is, of course, impossible to generalise about the methods and procedures followed by the ancient Egyptian artist in such a way as to encompass all periods and all parts of the country. Nevertheless, such was the conservative nature of the ancient Egyptian, not only in the practicalities of daily life, but in many ways of thought, and in the practise of tech-

nologies, that artistic conventions and methods introduced in the earliest historic period (c. 3000 BC) can be traced in actual use for the subsequent three millennia. There were frequent modifications and changes of practice and of detail, and there were periods when conventions were relaxed; but in times of cultural and political strength, standards were reasserted as if the country were being called to attention after a period of standing at ease.

There is, therefore, a real basis for discussing artistic methods in general terms, provided that allowance is made for the existence of many variations and exceptions. In the decoration of tomb and temple walls, and possibly also of domestic buildings, the careful preparation of the surface to be decorated was of prime importance. Walls of good stone, whether in a constructed building or in a rock-hewn chamber, needed to be smooth; those of mud-brick, or of poor stone, required to be overlaid with a good painting surface usually consisting of a thick layer of coarse mud plaster reinforced with chaff, covered with a thin coat of fine gesso (gypsum-plaster). The prepared surface in all cases might be further covered with a thin wash which, in the case of paintings, might eventually serve as the background colour. In the Old Kingdom, and occasionally later, this ground colour was a slatey– or bluish–grey; during most of the New Kingdom a stark white was used, with yellow occurring in many tombs of the Theban Necropolis.

Knowing in advance, presumably, exactly what was to be painted on a given wall, and working from some kind of preliminary sketch or plan, the artist would consider the area to be filled and would mark it out with boundary lines to contain the required scenes. On parts of the wall, but rarely over the whole, he then marked further guidelines indicating the registers or bands of decoration characteristic of the

linear form of representation practised by the Egyptians. Thus a wall might have as its decoration at one end the figure of the tomb-owner filling most of the height of the surface provided, while the remainder of the wall would be divided horizontally into several registers which contained scenes of various kinds at a scale much smaller than that of the principal figure. The facsimile painting of Nina Davies of one wall in the Theban tomb of Khaemwese, well illustrates this method (fig. 11). Khaemwese is shown, at large scale, seated on the left, observing various activities arranged in three registers, small scale, to the right.

Further marking out of the wall then followed to enable the artist, both to transfer the small design of the preliminary drawing to the larger scale needed on the wall, and also to provide him with aids to construct, in particular, the human figures in the scenes. Grids were used, marked out on the prepared wall-surface in red. It is thought that the lines of the grids, and other guidelines, were produced by stretching cords carrying red colour tautly and snapping them against the wall. There was undoubtedly a proportional basis to the unit of the grid, derived from the proportions of the standard human figure. For much of the Pharaonic Period, a grid of eighteen squares in height was used for the standing figure of a man, from sole of the foot to the hair-line on the forehead. There were, however, periodic variations in the number of squares used – twenty in the late Eighteenth Dynasty, twenty-one in the Twenty-sixth Dynasty and later – and the reasons for such variations, and indeed the general principles on which the grid as such were based, are matters of continuing debate among students of Egyptian art.

A very well-known 'document' for the study of the grid is a wooden tablet or drawing-board in the British Museum (no. 5601) which

11 Scene from the tomb of Khaemwese at Thebes in which the tomb-owner is shown at large
scale on the left, observing various activities, including wine-making and rope-making, set
out in three registers at small scale.

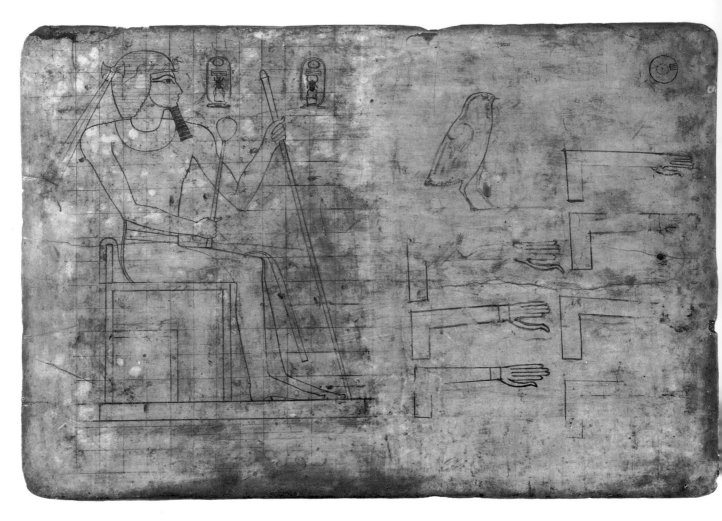

12 Wooden drawing board with a prepared plaster (gesso) surface. The left half is marked with a grid in red ink within which is drawn a careful representation of the King Tuthmosis III of the Eighteenth Dynasty (c. 1504–1450 BC). Trial hieroglyphs of an arm and a chick occupy the right side. Height 35.4 cm (no.5601).

shows a seated figure of a king drawn within a grid (fig. 12). Here, because the figure is seated, not standing, fourteen and not eighteen squares are used for the height. Comparisons between this very careful drawing – perhaps an artist's exercise – and other figures in grids, show that the measurements in terms of squares for the various parts of the body were fairly strictly established; and the conventions extracted from these measurements can be applied with a high degree of precision to well-drawn representations unmarked by grids.

The system (or canon) can be checked agains[t] the fragment of painting (no. 43465) whic[h] comes from an unidentified Theban tomb o[f] the Eighteenth Dynasty (fig. 13). Although th[e] whole of the seated figure is not preserved, an[d] parts of the grid are not very clear, it is easy t[o] establish that fourteen squares were used fo[r] the height up to the hair-line. In both repres[?] entations, the top of the knee comes at squar[e] 5, the bent elbow at square 7, the line of th[e] shoulder joining the neck at square 11. Not a[ll] details are identically placed in both, and [?]

13 Tomb painting showing a man, almost certainly the tomb-owner, seated behind a table piled with funerary offerings. The preliminary grid in red paint is clearly visible. Height 26 cm (no.43465).

other measurements followed, if strict convention was adhered to.

Unfinished tombs provide plenty of evidence to show how the artist went about his work after the surfaces were prepared and worked out. First the design was sketched in red paint, the intention being to assemble on the wall all the principal figures, and important elements in their approximate positions. Colour was then added, filling in the areas marked out by the red lines; shading was applied by stippling and hatching; detail was included where necessary; and finally the outlines were reinforced with new lines. Only rarely were painted figures and objects left without outlines. Some of the floral elements in the paintings from El-Amarna lack definition in this way, and the resulting effect, unprecise and almost impressionistic, gives them a strangely un-Egyptian appearance.

Although the paintings in a tomb were carefully designed with the purpose of providing the tomb-owner with resources of various kinds for his use in the after-life, they were not composed to achieve artistic balance and unity. They were not painted to be seen, but to be capable of magical activation on behalf of the tomb owner. Content and detail were of the utmost importance, and the various elements were represented, in so far as the artist was capable of doing so, as they were, or as the artist thought they were; things and activities were set out one by one; objects in rows, events one after the other, as can be seen in the various stages of wine-making in the tomb of Khaemwese (*fig. 11*). The tomb-owner as the principal person was always shown larger than anyone else, including his wife.

The manner of depicting the human figure, with the head shown in profile but the eye as from the front, with the shoulders represented frontally, but the legs in profile, was integral to the Egyptian convention according to which as much detail as possible should be included.

particularly noticeable difference lies in the width of the shoulders: the figure on the board measures $5\frac{1}{2}$ squares across the shoulders, while 6 squares are used in the painting. The grid provided a guide and a framework for the standard representation of the human figure, but the conventions could be varied, particularly in the placing of the incidental parts of the body. Height was the most important measurement to establish; at eighteen squares (or otherwise at certain periods) the human figure was satisfactorily placed in the scene;

in Egyptian tombs often prompt the question, 'How did the artists see to paint?'. The innermost chambers of many tombs are totally without daylight, and even those into which light may partly penetrate are rarely bright enough to allow painting without some form of artificial illumination. The absence of any sign of soot deposits on the ceilings of tombs which have not been used, e.g. as human habitations, since they were prepared, is puzzling, because the kind of lamp used in ancient times was liable to produce a smoky flame. Lamps were used by the workmen who prepared the royal tombs, and strict control was kept over the issue of wicks. It is hard to understand why such control over objects made from waste linen was necessary, but the matter is well documented. No similar control seems to have been exercised over the oil used in lamps. It is possible that the wicks mentioned were in fact specially prepared tapers, impregnated with oil or fat, and capable of producing a kind of flame more useful than that yielded by an open oil lamp with twisted linen wicks (*fig.* 14). Many vegetable oils were available for use in such lamps, those most likely to have been used in ancient times being linseed oil, extracted from flax-seeds, and sesame oil.

Whatever illumination was used by the artist, it remains a matter of wonder that such competence could yet be achieved. In the end, however, we must remember that the ancient artist worked in the conditions to which he was accustomed. He was strictly trained, followed his instructions, and was scarcely allowed to be temperamental. Paints were undoubtedly prepared outside the darkness of the tomb or temple; they were applied according to custom. And yet, for all the control and the predetermined plan, work of consummate skill and often of genius was produced. The outline scribe was no ordinary practitioner, but a true artist.

14 Part of the final vignette from the *Book of the Dead* of Ani. A hippopotamus-goddess, here possibly a form of the goddess Hathor, holds a lighted taper of twisted linen, perhaps the kind of torch used by painters working in dark tombs (no.10470, sheet 37).

The artist painted what he knew was there, not necessarily as it appeared to him. Many apparent peculiarities of Egyptian graphic representation and other unusual techniques employed by the Egyptian artist to achieve particular results, or to solve particular graphic problems, will be noted when specific examples occur in the subjects described later in this book.

The sureness and precision of the paintings

3

Mural painting

The tradition of mural painting in Egypt can be traced back at least to the late Predynastic Period (c.3200 BC). A tomb at Hierakonpolis in Upper Egypt, now sadly destroyed, was decorated with figures of boats and men engaged in various warlike and hunting activities. Some of the elements are similar to those found on decorated pottery of the same period (*fig.* 15). Tombs of the First and Second Dynasties at Saqqara, built of mud-brick, retain in some cases, substantial traces of paintings representing coloured matting on their exterior walls. By the Third Dynasty tomb decoration had been carried to the interior corridors of tombs at Saqqara, with fairly simple representations of domestic equipment provided to reinforce magically the actual objects placed in the tombs as the grave-goods of the deceased: the objects were looted, the paintings remained.

In the British Museum, the earliest fragments of tomb paintings came from the *mastaba*-tomb of Nefermaat and Itet at Maidum. Nefermaat, a son of Snofru, first king of the Fourth Dynasty, was buried with his wife in a splendid mud-brick tomb in which there were substantial elements of limestone, some carved in low relief and others decorated by a most unusual method whereby scenes and texts were cut out and filled with coloured pastes. This latter technique does not appear to have been used to any great extent elsewhere, and it may be thought to have been considered laborious, expensive, and unsuccessful. The best decorations in the tomb were executed on prepared gypsum plaster surfaces laid over mud plaster reinforced with chaff, covering the mud-brick walls of certain corridors.

The two British Museum fragments (nos 69014 and 69015, but until recently, Victoria and Albert Museum nos 560–1891 and 561–1891) are sad remnants of what were once large, richly coloured scenes. Even as fragments they show clearly the extent to which the draughtsmen and painters at this early period (c.2580 BC) had developed the precision and delicacy of drawing, and the subtle command of colour which were to characterise Egyptian painting for the next

15 *above*. A predynastic pot with painted designs, including a boat with oars, and other, possibly totemic, emblems. Height 16 cm (no.58212).

16 Part of a wall-painting from the tomb of Nefermaat and Itet at Maidum. It comes from a scene of bird-trapping. The man on the right holds the rope of a clap-net, while the man on the left holds a decoy duck. Length 59 cm (no.69014).

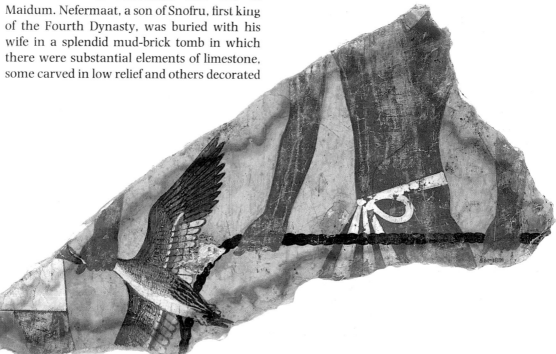

17 A young addax antelope is led forward by an attendant, part of a scene from the tomb of Nefermaat and Itet, in which unusual animals are shown being domesticated. Length 80 cm (no. 69015).

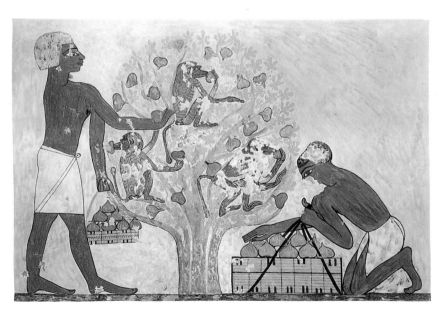

19 Facsimile painting of a scene from the tomb of Khnumhotpe at Beni Hasan. Two men pick figs and pack them in baskets, while baboons (tame and possibly sacred animals) help themselves to the fruit in the tree.

two thousand years. One piece (*fig. 16*) shows parts of two men from a scene in which, in all probability, birds were being trapped in a large clap-net. The detail which demands special attention here is the decoy duck held by the man on the left. Its primary feathers are represented by fine black lines drawn over a surface wash of dark grey, the secondary feathers are indicated by four bands of colour white, red, green and white. Part of the body is white and the remainder shows subtle texture and shading by the drawing of fine wavy grey/black lines over a grey wash. The tail feathers are indicated by bold black lines over yellow.

The background of this scene is a pale bluish-grey wash, used throughout the tomb for the mural paintings. The second fragment (*fig. 17*) shows part of a scene of a man holding an addax antelope. The animal is drawn with all the skill characteristic of Egyptian animal and bird painting and its colouring in the main part of the body – the forequarters and the back – is an unusual pale greyish-green almost an olive green. The distinctive marking on the nose of the beast is yellow. Here note should be taken of the care with which the hieroglyphic signs are painted. One of the signs which makes up the word for *adda* represents two hills with a valley between (\frown); the base colour here is pink and 'desert texture' is added with spots of red, black, white and green – the variegated pebbles of the desert, as Flinders Petrie, the excavator of the tomb of Nefermaat, pointed out.

Before Petrie worked at Maidum, the famous French Egyptologist Auguste Mariette recovered from the same tomb of Nefermaat one of the earliest and, by the standards of any time, one of the finest pieces of Egyptian painting. This, the so-called *Maidum Geese*, is now in the Cairo Museum, but the British Museum possesses a very fine facsimile painting of it executed by Nina Davies. Of this

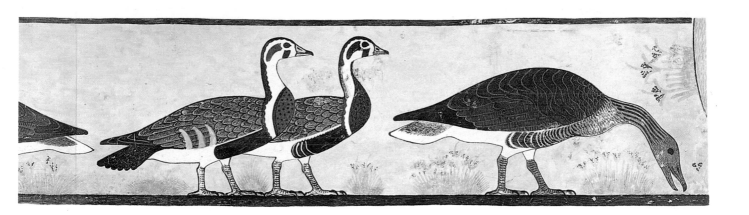

18 Facsimile painting of part of the scene of geese from the tomb of Nefermaat and Itet. Although of very early date (c.2600 BC) these 'Maidum Geese' are among the finest achievements of Egyptian painting.

remarkable scene (*fig.* 18) she comments: 'such is the mastery of its execution, such the craftsman's command of his materials, that it might well stand at the apex of the long centuries of achievement rather than at their base.' She notes that the artist's accuracy in depicting identifiable species of goose is far greater than that of his descendants in the great days of tomb painting at Thebes twelve hundred years later. The colours used cover a wider range than was generally common and unusual shades have been achieved by subtle mixes of primary colours: black and red produce a dull pink; black, yellow and red for dark brown; shading and stippling also give texture and depth to flat areas of colour. Here a true master has been at work.

The Museum's collections contain no substantial example of straight mural painting from the Middle Kingdom (c.2050–1786 BC), although fine painted reliefs from Deir el-Bersha (p. 65) could almost be admitted as suitable representatives for this time. The best surviving paintings are to be found in the necropolis of the nobles of the Oryx Nome at Beni Hasan. Again a copy made by Mrs Davies may illustrate the competence of the artists working in this provincial centre (*fig.* 19). Men are shown picking figs in the gardens of the

nomarch (governor of a district) Khnumhotpe who lived in the mid-Twelfth Dynasty (c.1875 BC). The tomb is rock-hewn and the murals are painted on the bare limestone with the intervention of only a very thin priming. In this scene, a fine balance has been achieved by the artist between tree and figures. The men who pick and pack the figs show awkward distortions of the shoulders, the painter having made what may seem to have been a clumsy attempt to adapt the normal conventions to represent both shoulders. The painters at Beni Hasan introduced many unusual themes which required the representation of men in unusual attitudes – groups of wrestlers may be cited – and apparent distortions of the kind found in this painting are very common. It would be wrong to regard these seemingly gauche dispositions of limbs as being due to the inability of the artist to draw the unusual. The shoulders here are shown as the artist thought it right to show them. The draughtsmanship and execution are in other respects very accomplished and the tree full of thieving baboons is splendidly realised. Colour is here applied very simply, with few cases only of shading and intensification of texture.

Most of the tomb paintings in the British Museum date from the New Kingdom, and of

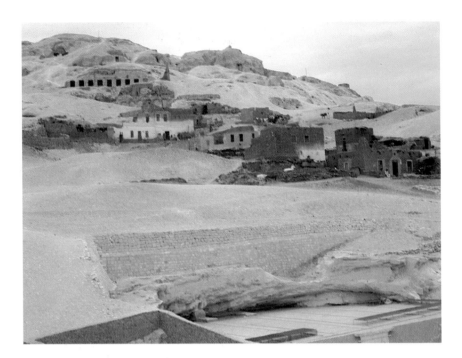

20 A part of the Theban Necropolis with the tombs of nobles intermingled with the houses of the modern inhabitants of the region.

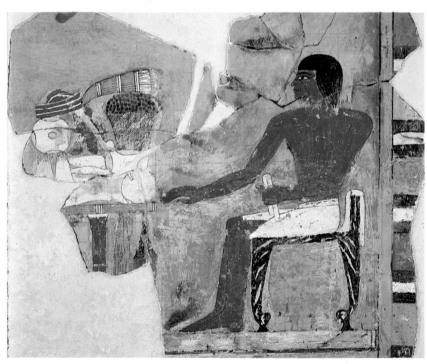

these, the majority from the Eighteenth Dynasty (c.1567–1320 BC). This holding matches the distribution of surviving paintings in Egypt, the majority of which are to be found in the great Theban Necropolis, and mostly in tombs prepared for the high officials of the Eighteenth and Nineteenth Dynasties. The tombs containing paintings are chiefly those cut in the parts of the necropolis where the limestone is not very satisfactory. To receive decoration, therefore, the walls of the tomb-chapel needed to be faced with reinforced mud-plaster, covered with a thin layer of hard gesso-plaster. The technique of preparing walls in this way was completely mastered at Thebes, and first-class surfaces were provided for the artists to work on.

During the Eighteenth Dynasty Thebes became a city of the highest importance, and large numbers of courtiers and officials lived there and were buried on the west bank of the Nile (fig. 20). Hundreds of tombs have been identified, the majority of which contain painted decoration, often greatly damaged. Those fragments that can now be seen in the British Museum are, as has been pointed out already, parts only of coherent schemes of decoration. As they are now to be seen in a museum gallery, isolated from the rest of the scenes with which they once belonged, they are often described and considered as if each were a separate composition. In the descriptions given here, the individual pieces will be related, as far as possible, to the kinds of scene of which they originally formed part.

Three groups of Theban tomb paintings of the Eighteenth Dynasty make up the bulk of

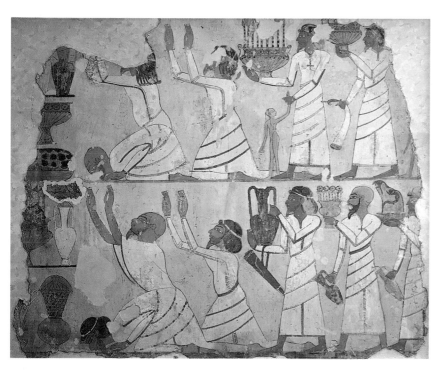

21 *left.* Tomb painting from a Theban private tomb. The tomb-owner stretches out his hand towards a table piled high with food offerings, including ribs of beef, a bunch of onions and a finely woven basket of grapes. Height 39 cm (no.43467).

22 Semitic envoys bring gifts to Pharaoh. Vessels of gold are painted yellow, those of silver are white; those painted dark blue (now almost black) were probably made of a material called 'Egyptian blue'. Height 114 cm (no.37991).

the Museum's collection. The earliest consists of four small pieces, three of which show men seated on low-backed chairs; all bear remains of the grid used to establish the figure in its scene; the red lines of the grid, drawn on the pale brown gesso base, are only partly obscured by the greyish–blue wash used for the background. One piece with a well preserved grid has already been illustrated (*fig.* 13). Another, the largest of the group (no. 43467, *fig.* 21), provides the best scene for detail and stylistic examination. A certain stiffness and simplicity about the pose of the figure and a lack of subtlety in the way the paint has been applied suggest a date in the earlier part of the Eighteenth Dynasty (before 1500 BC). Yet there is a precision in the representation of the offerings, the use of very fine lines for outlining the figures and objects, and an unusually rich use of colour in the delineation of detail which give the piece unexpected interest. The chair,

for example, is painted black with pale yellow lines added to indicate graining; the woven texture of the basket containing grapes is rendered by a pattern of tiny squares painted in red, blue and white. The right-hand edge of the scene is finished with a border of coloured rectangles and narrow strips, a kind of border first used in tombs of the Old Kingdom. This painting is clearly unfinished.

Six pieces of painting are thought to have come from the tomb of Sobkhotpe among whose titles was 'Mayor of the Southern Lake and the Lake of Sobk', which placed one of his centres of influence in the Faiyum, the great area of lake and cultivation lying to the west of the Nile valley fifty miles to the south of Cairo. His other titles and duties brought him to the capital at Thebes and in his tomb he included scenes of great interest referring both to international events and domestic activities.

The most striking painting comes from a series of scenes dealing with the presentation of tribute by foreigners to Sobkhotpe's king, Tuthmosis IV (*c.*1425–1417 BC). His reign marked a high point in the achievements of the Theban artists, and this painting well represents what they were capable of doing with a scene containing many unusual, un-Egyptian elements (no. 37991, *fig.* 22). Here Semitic envoys, conventionally described as Syrians, bring a variety of gifts to Pharaoh, all being the products of Asiatic craftsmen. Characteristically the individual envoys are shown one by one, as if in procession, but the monotony of such a regular arrangement is broken by the representation of two groups of three bowing in obeisance to Pharaoh. Movement is clearly indicated in all the figures, no two of whom have identical attitudes. A particular detail which provides a focus of interest is the figure of a small girl who looks back at one envoy who holds her by the hand; part of a companion figure of a small boy (the skin is darker than in the case of the girl) can

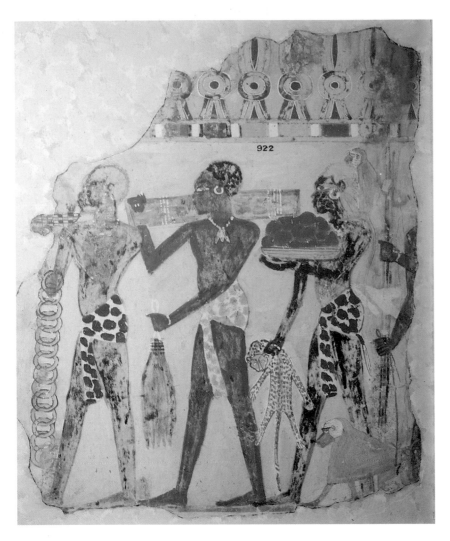

23 Men bring the tribute of Black Africa for presentation to Pharaoh. The gold, from mines in Nubia, has been cast into rings for ease of transport. Height 74 cm (no.922).

be seen at the right end of the upper register. The artist has taken great pains in depicting these foreigners with the utmost fidelity of which he was capable. His success is manifested in the heads of the individuals; the features are undoubtedly Semitic, the hairstyles are characteristic to judge from contemporary representations from Western Asia. The beards are painted with thin sparse lines, giving the suggestion of wispiness; the skin colour is a light brownish-yellow, quite different from the darker reddish-brown commonly used for Egyptian men.

This freedom of representation can be seen in a second fragment from the same scene of tribute, in which black men from tropical Africa are portrayed (no. 922, fig. 23). The exotic products of the south were greatly prized in ancient Egypt, and regular trade routes across the Sudan were established as early as the Old Kingdom. In the fiction by which the King of Egypt claimed to have control over all foreign countries, it was necessary to show the arrival of goods from abroad as if they were tribute from subject princes. This idea lay behind the kinds of scene found in Sobkhotpe's tomb. Here four representatives of tropical Africa (one is preserved only in part) are shown carrying some of the characteristic, much valued, products: the first bears gold; the second supports a bundle of ebony logs on his shoulder and holds a bunch of giraffe tails (for fly whisks) in his left hand; the third carries a basket of fruit and a leopard-skin, and a monkey sits on his shoulder holding on to his head; the fourth leads a baboon. Characteristically, the bodies of the men are painted in different shades, ranging from pure black to a lightish brown; in all cases the paint appears to have been applied in thick daubs, and the outlining of the figures is uncommonly imprecise. The general effect is convincingly impressionistic. The negroid features are accurately portrayed; again, as in

24 Jewellers and metal-workers make beads and precious objects. Those men using bow-drills to pierce hardstone beads use an abrasive material kept in small cups at their feet. Height 66 cm (no.920).

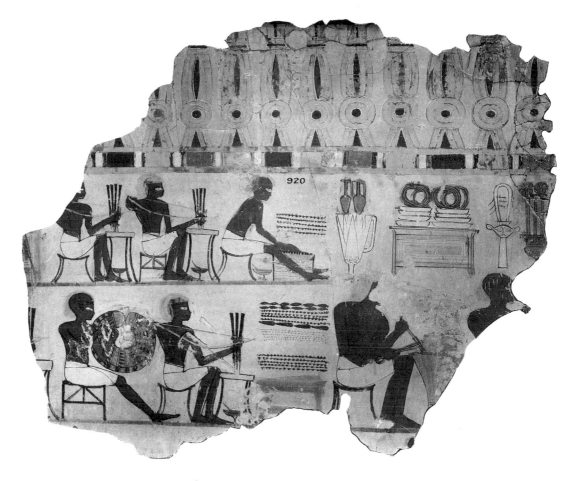

the scene of Semitic envoys, the artist has succeeded admirably in representing unusual racial types and strange objects. It may be noted that the ebony here is painted black with pale yellow graining like the wood of the chair in *fig.* 21.

The third piece from the tomb of Sobkhotpe illustrated here (no. 920, *fig.* 24), comes from an entirely different sequence of scenes in which activities connected with the workshops and day-to-day businesses supervised by Sobkhotpe were represented. Here jewellers and metal-workers are engaged in making beads and vessels of precious metal. The style of the painting is altogether less formal than that used for the great ceremonial scenes; but

it possesses a charm which is wholly typical of such scenes in tombs of the same period. Jewellers occupy most of the two registers. Three men (and part of a fourth) are shown using multiple drills, worked by bows, to drill stone beads; the material is probably carnelian, if one may judge from the red colour of the strings of beads shown in both registers. A man appears to be polishing the drilled beads on a wooden block in the middle of the upper register. At the left-hand end of the lower register a fifth jeweller assembles an elaborate collar from beads and other elements of different materials. On the right of both registers metal workers and their products are shown. Above are gold and silver vessels; the bowl

with artificial flowers 'arranged' in it is very similar in style to some of those brought by the Semitic envoys shown in *fig. 22*. In the lower register one man uses a blow-pipe to intensify the charcoal fire in his open brazier. The informality which distinguishes this scene, characterised by the casual and varied attitudes of the workmen, is typical of the best non-royal painting in the Theban Necropolis. The draughtsmanship is not as precise as in the tombs of the highest officials who were able to employ the best qualified craftsmen; but in artistic terms, the absence of exact drawing is not wholly to be regretted. The border at the top of the scene is also typical of Theban tombs of the period, consisting of a line of coloured rectangles surmounted by a frieze of objects called *khekher* in Egyptian, apparently bound bundles of straw or similar material used originally to decorate the tops of reed shelters.

Three other fragments probably from the tomb of Sobkhotpe are on display in the British Museum. One (no. 919) shows offering-bearers, another (no. 921) contains a further part of the scene of tribute bearers from tropical Africa, and the third (no. 37987) carries a representation of a Syrian with a horse, with part of another carrying a small child. This last painting, which is not indubitably from the Sobkhotpe tomb, is stylistically not convincingly the same as the piece showing Syrian tribute bearers, described above.

The outstanding group of paintings in the British Museum, eleven in all, comes from a tomb which has never been identified to the complete satisfaction of Egyptologists. It is certainly Theban and belonged to an official with the titles 'scribe and counter of grain'. His name may be restored from damaged contexts as Nebamun. On stylistic grounds it may be dated to the reign of King Amenophis III (*c.*1417–1379 BC). There can be little doubt that the artist, or team of artists, who dec-

orated this tomb, was exceptionally skilled both in the layout of the various scenes, and in the use of paint. The paintings from few tombs can rival the virtuosity of this sequence of scenes.

From this series, the best known, and certainly the finest painting, comes from a double scene, a common subject to many Theban, and other tombs – the tomb-owner in the marshes, catching birds and spearing fish. Here, only the bird-catching half is preserved (although the tip of the hunter's fish-spear can be seen at the bottom left), but so splendidly is it designed and coloured, and so rich in detail, that it, exceptionally among fragmentary tomb-paintings, can be appreciated as a coherent composition as it stands (no. 37977, *fig. 25*).

The figure of Nebamun, as he may conveniently be called, is shown standing in a frail papyrus-boat sailing in the marshes. He is accompanied by his wife, and a young daughter. Nebamun wears only a brief kilt and an elaborate collar for his pursuit, but his wife seems grossly over-dressed for such an occasion; it is as if she had just come from, or perhaps was dressed ready for, a formal party of the kind shown elsewhere in the tomb (*figs 26, 27*). The painting is teeming with incident and detail and merits very close examination not only for the identification of all that happens, but also for a proper appreciation of the painterly qualities displayed in this masterpiece by an anonymous artist. Observe the liveliness of the scene in the thicket where panic has overtaken the roosting birds; compare the placid life of the fish in the water below the boat – they have yet to swim into the range of Nebamun the harpooner. The skills of the artist are apparent in every aspect of the painting: in the overall design, in the richness of the detail, but particularly in his exquisite use of paint to produce results unparalleled in any other Theban tomb. Note especially the

25 Nebamun hunts birds in the marshes. He holds a snake-headed throw-stick in one hand and three decoy herons in the other. His retriever cat has already trapped three birds. Height 81 cm (no. 37977).

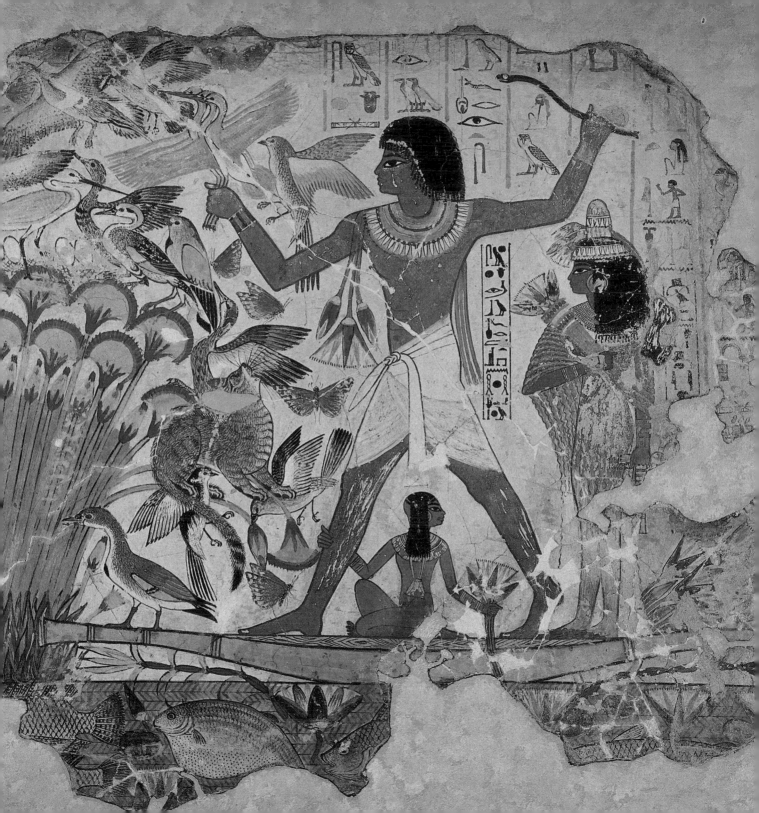

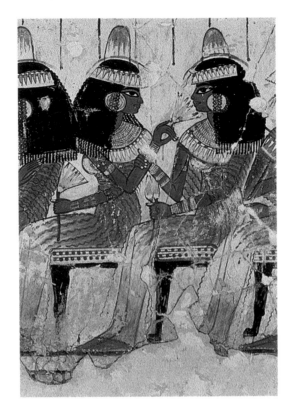

26 Two ladies at Nebamun's banquet chat to each other. The cones of scented ointment on their heads were intended to melt as the party continued, scenting and cooling their bodies. Height of whole fragment 76 cm (no.37986).

subtle colouring of the birds – not always anatomically correct, but so convincing – the delicacy of the butterflies, the irridescent sheen on the scales of the fish, and above all the attitude and detailed marking of the retriever cat. The text in black hieroglyphs beneath Nebamun's raised arm describes him as 'taking recreation and seeing what is good in the place of eternity (i.e. in the after-life)'. He should indeed have been well content with his artist and his tomb.

Among the most important scenes found in all properly equipped tombs were the feast and party. On the one hand it was important that the deceased tomb-owner should be provided with regular food and drink for his proper posthumous survival; on the other hand, in the course of that posthumous survival it was also important that he should enjoy himself from time to time by entertaining his friends at a banquet. Three parts of Nebamun's banquet scenes are preserved in the British Museum. The largest (no. 37986) depicts in two registers, different groups of guests. In the upper register they appear to be married couples, three pairs seated side by side, the man on a yellow painted stool (possibly of acacia) and the woman on a black-painted chair (probably ebony). Men and women are represented as being almost of equal height. They are served by girls and youths. The whole register in its obligatory linear arrangement, in spite of its formality, is yet infused with a detectable buzz of animation. But not so clearly as the lower register, where ladies sit alone together, probably Nebamun's unmarried female relatives. The two ladies who are shown in *fig. 26*, realise in themselves the charm of the whole. They are dressed much as Nebamun's wife was dressed to go fowling: their yellow gowns, shading off to white from their knees, with their legs showing palely pink through the transparent linen, long black wigs terminating with thin ringlets, bound with floral chaplets and topped by cones of sweet smelling ointment. Here one of the ladies turns to the other and offers her a lotus-flower to smell; the other grasps her companion's forearm in what must be seen as a gesture of affection.

The second banquet scene again has mixed couples in the upper register, followed by a number of male guests, every other one of whom is shown without a wig (no. 37984, *fig. 27*). The particular interest here, however, lies in the lower register where the cabaret to entertain the guests is well under way. A *pas de deux* is the act we are viewing. Two young girls, very scantily clad, weave in a dance of oriental sensuousness. Especially interesting is what the artist has made of two of the four ladies who make up the accompanying group providing the music and the rhythmic backing

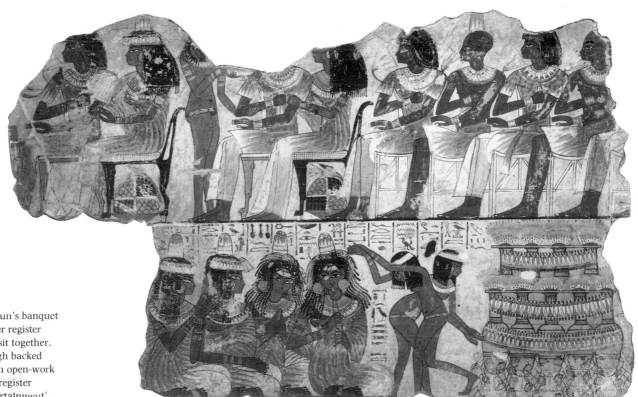

27 Part of Nebamun's banquet scene. In the upper register men and women sit together, the women on high backed chairs, the men on open-work stools. The lower register contains the 'entertainment'. Height 61 cm (no.37984).

with double flute and handclapping. The flautist and one clapping lady are shown full-face, quite contrary, as we should believe, to the Egyptian conventional way of representation in profile. Undoubtedly the artist has departed from the usual in order to impart a dramatic element to the scene, heightening the sense of excitement and movement, which is further suggested by the irregular disposition of the strands of these two ladies' wigs. Their heads are clearly shaking from side to side. A further graphic detail worthy of comment is the shading on the undersides of the bare feet of the musicians. The same detail can be seen in the third fragment of banqueting (no. 37981) in which lutenists and another flautist are shown.

The way in which a man lived during his life-time was reflected in what was portrayed in his tomb. His house, for example, might have a garden and in the garden would be a pool with shady trees, where he and his wife could amuse themselves and keep cool in the heat of the day. Nebamun's pool teems with fish and fowl; lotus flowers float on the surface, flowers grow around the margins, and trees including date-palms, sycomores and mandrakes shade it on three sides (no. 37983, *fig. 28*). This painting illustrates yet another graphic peculiarity of the typical Egyptian way of representing what is to be shown intellectually rather than visually. The pool is shown as from above, in plan, but as it was conceived in the artist's mind. The birds, fishes, and plants in the pool are shown in profile, as was normal. The trees around the pool are disposed somewhat awkwardly: on two sides the edge of the pool is taken as the base line on

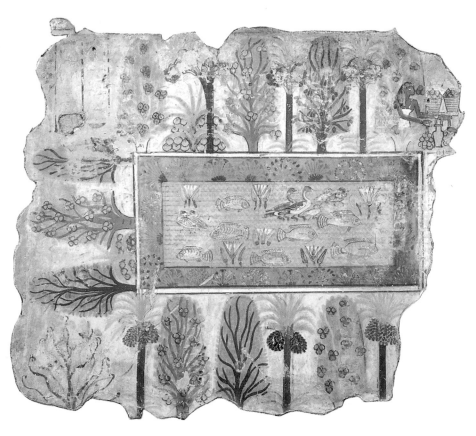

28 The pool in Nebamun's garden. Date-palms, sycomores and mandrakes hedge the pool which teams with fish and fowl. This bounty is provided by the goddess of the sycomore who can be seen in the top right-hand tree, weighed down with her produce. Height 64 cm (no. 37983).

which the trees stand, drawn as frontally; on the third side, in order to present the trees in a visually acceptable way, their base line is brought well away from the edge of the pool, so that the trees are shown as if growing at some distance from the edge. The effect may appear strange to modern eyes, but there is a logic here, fully consonant with the Egyptian way of representing the visual world in two dimensions. It would surely not look strange to a young child grappling, untutored, with the same problems of representation today.

It will have become apparent by now that the artist who decorated Nebamun's tomb was an outstanding draughtsman, a brilliant colourist, with a remarkable sense of design which practically transcended the Egyptian conventions governing the use of space. He was above all a first-class painter of animals, excelling in grouping creatures in the mass. Two scenes exemplify this special talent.

The first (no. 37976, *fig.* 29) deals with the parade of cattle before Nebamun, cattle probably belonging to the estates of the Temple of Amun at Thebes over which he had some control. The cattle are shown in groups in two registers and a record is made by scribes. The groups of cattle are introduced by subservient attendants, and controlled by herdsmen. In the middle of the lower register the herdsman, holding a coil of rope in one hand, raises the other and speaks. His words are written above, and they begin: 'Come, hurry up, do not speak in front of the praised one (i.e. Nebamun)! People speaking are his abomination'. It may be presumed that a large figure of Nebamun was placed to the left of this scene, and this figure in the original composition would have formed the focal point. In this isolated fragment, the young herdsman fortuitously acts as the focus, and the slight authority of his finely poised body is happily reinforced by the stirring words of his statement. The principal interest in the scene, artistically, lies in the groups of cattle, short-horned above, and long-horned below. It was the common practice of the Egyptian artist to differentiate between overlapping figures or objects by using different colours, thereby helping the observer to identify separate figures. Here, the artist has gone far beyond simple individual identification. He has not been content to give each beast a single colour; he has provided a remarkable range of dappled, brindled, piebald, mottled and spotted hides, a fanciful herd which is yet completely convincing.

He has performed a similar piece of painterly virtuosity in the fragment which shows the census of geese (no. 37978, *fig.* 30). Again the scene lacks the dominating figure of Nebamun to the left, which may in fact have served to

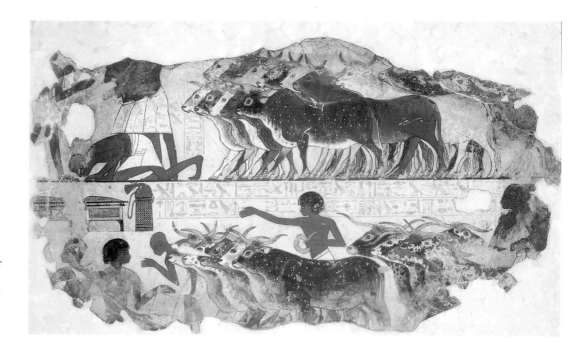

29 Cattle are brought for inspection before Nebamun. The scribe in the upper register holds open his papyrus ready for the inspection; his fellow in the lower register squats in readiness for the same. Height 58.5 cm (no.37976).

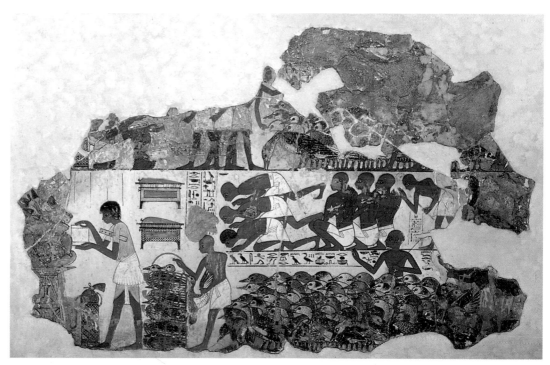

30 The scribe conducting the goose census on Nebamun's estate stands on the left with open papyrus. His writing palette is tucked under his arm and a basket-work cylindrical container for papyrus rolls is by his feet. Height 71 cm (no.37978).

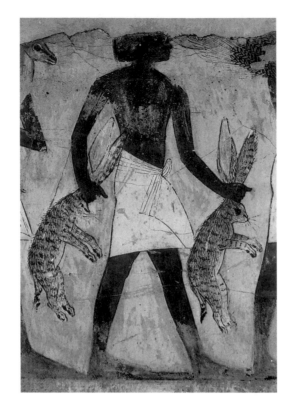

31 Part of a scene from Nebamun's tomb showing men bringing produce from the fields: barley, vegetables, a young deer and the hares shown here. Height 41 cm (no. 37980).

oversee both this and the preceding scene. The geese in the lower register, waiting patiently their turns to be packed ignominiously into baskets, are also differentiated by colour and markings, although much more muted colours are here used than for the cattle. Just enough are shown with heads turned, pecking the ground, and flapping their wings, to prevent the whole herd looking like a posed school photograph. The most distinguished human figure in the scene is the scribe on the left who presents his written record to Nebamun. He bends slightly forward, just enough to suggest deference. He, unusually, wears a short white kilt over a grey shift. It would be fanciful to read anxiety in his seemingly worried features; but it may well be supposed that at the moment registered in this scene, the moment when accounts were served up, he might well have wished that his training had directed him to be an outline scribe rather than a bureaucrat. Finally, it may be noted that the group of obeisant and squatting farmers in the middle of the scene receives an admonition from their low-bending colleague behind them: 'Sit down and don't talk!'

A further fragment from Nebamun's tomb which also demonstrates the keen observation of animals, shows a number of men carrying produce of various kinds, presumably to stock the tomb with offerings for the after-life (no. 37980). The portion illustrated in *fig.* 31 depicts a man carrying two hares by the ears. Not only are the physical details of the animals accurately reproduced, but their attitudes in being so carried caught precisely; their fore-paws stretch forward pathetically and their rear legs hang down limply.

The final fragment from the same tomb comes most probably from a series of scenes depicting the activities on the land. The overseeing of crops and the estimation of tax based on crop yields were fundamental to the Egyptian economy, and also the bane of the farmer's life. Here at the corner of a field of standing barley, ready to be harvested, and equally ready to be estimated for tax (no. 37982, *fig.* 32), two chariots stand waiting for their owners to return. One with horses may belong to Nebamun, the other to an official only a trace of whom can be seen on the independent fragment at the top left; he is 'chief of the grain-measurers of the granary'. His chariot, if it truly belongs to him, is drawn by a pair of animals which are probably onagars, a species of wild ass, one of which feeds from a basket – a typical modest detail of the kind frequently inserted into tomb scenes by the Theban artists. Both onagars are painted a greyish-blue (presumably because in nature there is little variation in the colour of

these animals), while the two horses are sharply distinguished, one being reddish-brown – you might say chestnut – and the other greyish-black, cleverly marked with black lines and flecks. The principal figure in the scene is an assistant of the inspecting official, his sparse hair indicating his old age. He is shown carrying a staff of office and bending over a white boundary stone, marking the edge of the harvest field. He checks it and declares: 'As the great god who is in heaven endures, the stone is correct, its position (?) stands fast'. All therefore is in order and crop assessment can now go ahead.

The highly-skilled craftsmen who prepared the tombs of the king of the New Kingdom in the Valley of the Kings at Thebes, lived in an enclosed settlement on the verge of the Theban mountain; it is today called Deir el-Medina (*fig.* 33). Here also they died and were buried; and, inasmuch as they knew more than most of their contemporaries about tombs and their decoration, they were able to have in death something very much better than their fellow craftsmen who lived and worked elsewhere. The chapels of their tombs are full of brightly coloured decoration, incorporating more mythological and liturgical scenes than was commonly the case in Theban private tombs of contemporary date. They were not, in most cases, painted as well as the tombs of the great nobles, but what they lack in this respect is often compensated for by charm of detail. The British Museum collections have only three small fragments to represent the tombs of Deir el-Medina. All

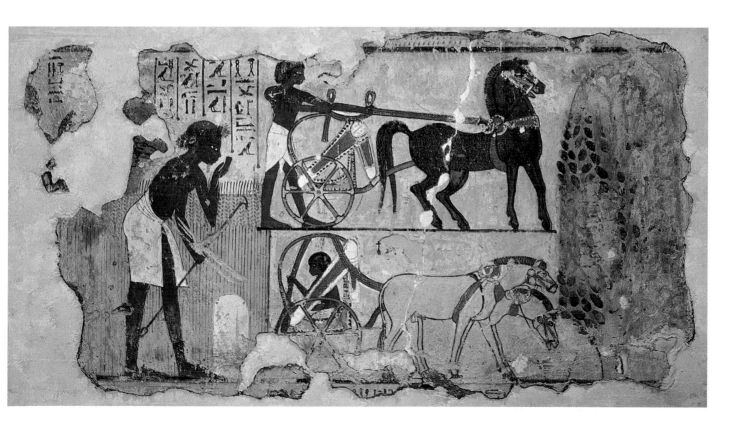

32 Crops are assessed for tax purposes on Nebamun's estate. The horses in the upper register are lively and need controlling while the onagars in the lower register are so docile, their groom can sit quietly while they graze. Height 43 cm (no.37982).

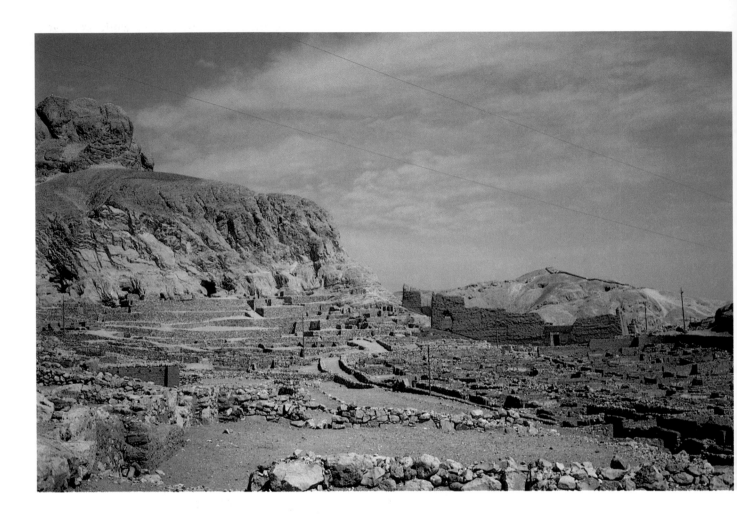

come from the chapel of the tomb of Inher-khau, Foreman of the Lord of the Two Lands (i.e. the King) in the Place of Truth (i.e. the King's tomb), who lived in the middle of the Twentieth Dynasty (c.1160 BC).

The most interesting of these fragments (no. 1329, *fig.* 34) shows the head and shoulders of a man and those of a small child; a trace of the arm of a third person at the top right-hand corner provides the clue that what is here is part of a scene in which a man (probably Inherkhau himself) sits with his wife (We'eb, if the man is Inherkhau) who holds the child on

her knee. Her left hand just touches the child's shoulder, while her right hand rests on her husband's left shoulder. This second hand may seem inordinately far from the lady's own shoulder, but this distortion is due to the Egyptian graphic convention of showing the shoulders frontally. If the man's body were turned to profile, like his head, then the lady's hand would appear in a much more natural position, as we should observe and expect it. There is an informality about much of the decoration in the tombs of the royal craftsmen which is very appealing. The impression is

33 The village established for the workmen who made the royal tombs in the Valley of the Kings at Thebes. The hill on the left contains the tombs of some of the workmen.

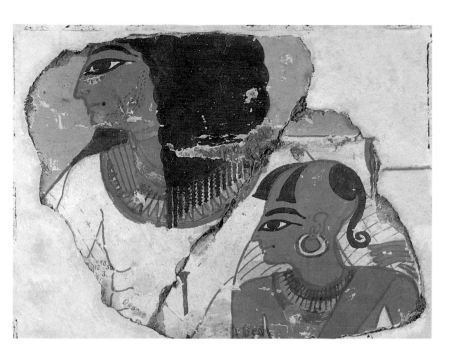

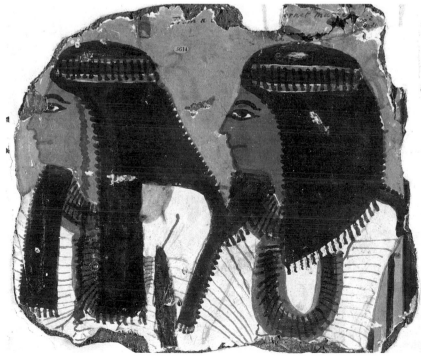

gained that this sort of work was carried through with a degree of freedom, and probably speed, which would have been wholly inappropriate for the grander commissions on which the craftsmen were normally engaged.

The somewhat crude yellow colour used as the background here is also very common at Deir el-Medina. Colour in fact is not used very subtly, a characteristic feature of all painting of the later New Kingdom. The second fragment from the same tomb illustrated here (no. 1291, *fig.* 35), shows the upper parts of a man and a woman seated side by side, again possibly Inherkhau and his wife. The casual, almost sketchy, draughtsmanship and flat use of colour are very apparent.

Another tomb of the Twentieth Dynasty was the source of three further paintings in the British Museum. Kynebu, its owner, was a priest 'over the secrets of the estate of Amun' in the reign of King Ramesses VIII (*c.* 1145 BC), and most of the decoration in his tomb was concerned with religious and ritual matters. One scene showed Kynebu before Osiris, King Amenophis I (of the Eighteenth Dynasty) and his mother Queen Ahmes-Nefertari. The figures of the god and of the two deified royal persons are preserved on the fragments in the museum (nos 37995, 37993, 37994). Amenophis I and his mother were held to be the patron deities of the Theban Necropolis, and they are often shown in tombs and on funerary inscriptions as subjects of particular veneration. The figure of Amenophis I (*fig.* 36)

34 Inherkhau and one of his children whose head has been shaved, leaving two strands over the forehead, and one long curling lock, the 'lock of youth'. This lock distinguishes a child who has not reached puberty. Height 19.5 cm (no. 1329).

35 A man and a woman seated side by side; a fragmentary scene from the tomb of Inherkhau at Deir el-Medina. Very unusually, the woman is shown as being as tall as the man, contrary to Egyptian convention. Height 24 cm (no. 1291).

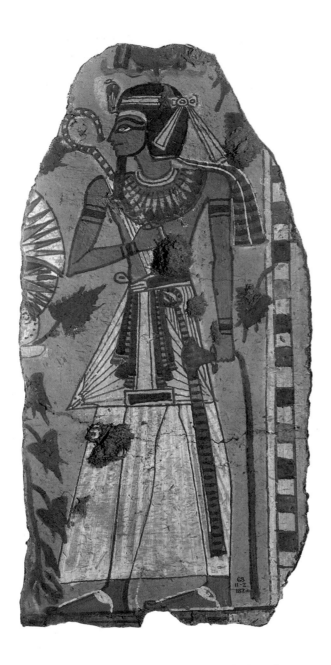

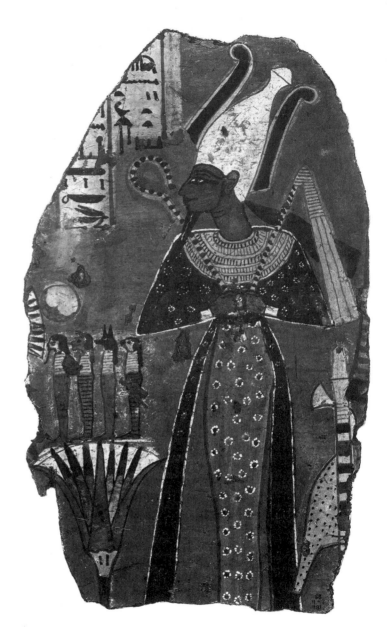

36 Painting of King Amenophis I from the tomb of Kynebu. It is thought that this king was responsible for the formation of the special gang of workmen employed on the royal tombs. Height 44 cm (no. 37993).

37 The god Osiris holding the regal symbols, the crook and flail. Before him, perched on a lotus flower, are miniature figures of the four sons of Horus whose function was to look after the embalmed internal organs of the deceased. Height 44.5 cm (no. 37995).

shows him in a rather wooden standing attitude, holding the crook, one of the symbols of royalty, and a limp papyrus flower. The draughtsmanship is careful but mechanical, while the colours are applied flatly with no attempt at shading. The fragment showing the god Osiris, (fig. 37) demonstrates equally how far Theban painting had travelled since the great days of the late Eighteenth Dynasty. The skills of the well trained draughtsman, the outline scribe, were, however, not entirely lost. In the next chapter first-rate examples of fine line-work from the late New Kingdom, down to the Ptolemaic Period (c.1100–100 BC) will point clearly to the preservation and continuance of the splendid tradition established earlier in the Pharaonic Period.

While Theban and other tombs have preserved a wealth of examples of mural painting very little has survived from the houses and palaces of ancient Egypt. Happily, preserved in the British Museum collections, are rare examples of painting from the houses and royal palaces at El-Amarna, the site of the great city established by King Akhenaten in the mid-fourteenth century BC. All domestic buildings in ancient Egypt were built of sun-dried mud-brick, and the interior walls of at least the principal rooms of the best houses were decorated with brilliantly coloured scenes and designs. As such decorations were not designed 'for eternity' like those in tombs, the surfaces on which they were painted were not so carefully prepared. Generally the mud-bricks were covered with a layer of mud plaster on which the decoration was painted directly without the intervention of a layer of gesso-plaster or even of a priming wash. Such decorations were not intended to last, and the recovery of fragments of pavements and wall paintings from El-Amarna, all in a very fragile condition, is due to the extraordinary skills and patient labour of the excavators of that most fascinating city.

The most precious piece of painting comes from the 'Green Room' in the Northern Palace, so-called because of the dominant colour of the decoration which covered its walls. The Museum's part of this decoration (no. 58830) is, sadly, in a poor, although stable, condition, due to the action of white ants which attacked the plaster backing, leaving the painted surfaces scarcely supported. It colours and design are barely to be distinguished. Happily, a facsimile painting of some of the decoration of the 'Green Room' was made by Nina de Garis Davies before the actual painting was removed, and this facsimile, exhibited along with the fragmentary original enables the remarkable quality of the work to be appreciated, if only at second hand (fig. 38).

Here is secular painting of a most unusual and remarkable quality. Completed by painters who might well have been descendants at one generation's remove of those who painted Nebamun's tomb, the room's decoration showed, apparently, a unity of design in its overall conception quite unlike the conventional, linear 'processional' manner which characterised earlier tomb and temple decoration. The walls of the 'Green Room' reproduced as in Chinese wall-paper – as Norman de Garis Davies suggested – a continuous but unified, panorama of life in the marshes. The papyrus flowers seem to sway and bend in perpetual movement, and birds to flit about in colourful flight, or settle on down-turned stems. Lotus flowers push their way up between the papyri; the pallisade-like background of massed vertical stems gives structure to the whole.

The houses of important officials and nobles at El-Amarna were also decorated with paintings, although not on the same scale as the royal palaces. It is clear that a common form of decoration in the principal rooms consisted of a frieze of lotus flowers at the top of the walls, with floral garlands and pendant swags of

ducks placed at intervals below. The remains of one such garland and swag (no. 58832, *fig.* 39) illustrate, in spite of the poor condition, the brilliant colours of the original.

From their outsides these houses presented a fairly undramatic aspect, four-square and white-washed. There is some evidence, however, that around the doorways and, perhaps, windows, there may have been painted plaster decoration. The large fragment of painted plaster (no. 58846, *fig.* 40), shows a characteristic Egyptian cornice separated by a *torus*-moulding from a deep, partly floral, frieze. There is nothing particularly remarkable or 'Amarna' about this decorative scheme, but in

so far as it comes from a domestic building it is exceptional.

In the matter of painted decoration in domestic buildings at El-Amarna, the remains of painted pavements still partially preserved in some of the royal buildings were particularly interesting. It has been stated that these floor decorations were carried out in a kind of fresco technique, that is, that the paint was applied to wet plaster, small area by small area. Such a technique secures the binding of the colours in such a way that they are firmly incorporated and fixed in the plaster. It would therefore be particularly suitable for floor painting, to withstand the wear of people

38 Part of the mural decoration in the 'Green Room' of the Northern Palace at El-Amarna. A kingfisher swoops down through the papyrus thicket to fish in the waters below.

39 Remains of a floral garland decoration from a frieze in a private house at El-Amarna. It is incorporated with a swag of pendent ducks. Height 45 cm (no. 58832).

walking over it. Careful examination has, however, shown that the plaster used at El-Amarna for such floors was of a gypsum base, and experiments have shown that such plaster, if painted upon while still slightly damp would produce a result not wholly unlike fresco, although not truly fresco.

A piece of pavement from a royal building at El-Amarna, called Maruaten (a kind of pleasure palace), represents very satisfactorily the style and quality of painting over which the great ones of Akhenaten's court were given to walking (no. 55617, *fig. 41*). The colours are cool blues, greens and yellow, with red details on the papyrus flowers and black markings on the birds. The design is not specially original and the painting shows much evidence of having been carried out quickly, with more *brio* than care. The whole impression in fact is of quick, almost spontaneous work, effected perhaps even without provisional drawing. It lacks what is expected of the best Egyptian painting, but it does not lack charm.

41 Ducks fly out of a papyrus thicket on a fragment of painted pavement from the building called Maruaten at El-Amarna. Height 93 cm (no.55617).

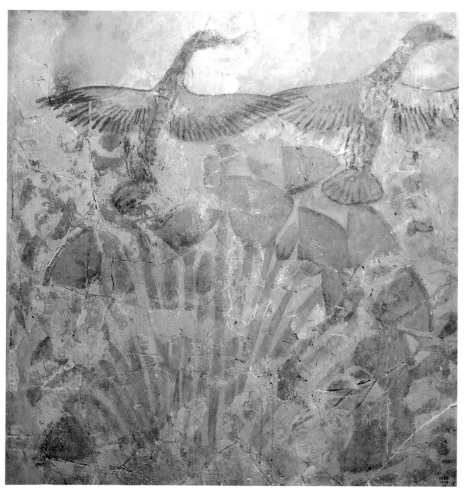

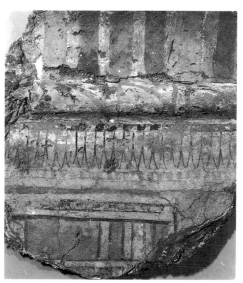

40 Painted plaster fragment from the outside of the house of a senior official at El-Amarna. It probably was originally part of the decoration above the principal doorway. Height 38 cm (no.58846).

4
Line drawing

In the discussion of scribal training earlier in this book it was suggested that initially both the scribe/clerk and the scribe/artist were trained together. Those with particular talents might be directed to the artistic side and would, if all went well, become outline scribes, the skilled brush men who carried out most of the specialised art work in the decoration of tombs and temples. Whether the final scheme of decoration was to be carved relief or tempera painting, the work began with the marking out of the walls and the drawing of the design. If the wall was to be carved, then the initial design would disappear under the carver's chisel. If it were to be painted, then again the purity of the initial drawing would in all probability be obscured by paint and the final addition of outlines. No matter how fine

43 A figure of the vizir Ramose set out within a grid, drawn in black paint, and partly carved. A pre-Amarna representation from his tomb at Thebes.

were the completed reliefs and paintings, there is much to be said for the view that the true artistry of the ancient Egyptian artist lay in the initial drawings. Here could be observed the mastery of the brush, the control of line, the sensitive placing of detail.

Happily much ancient work was left uncompleted. Such unfinished work, wherever it occurs, provides wonderful insights into the methods of the outline scribe as well as showing his particular skills. In this chapter some instances of unfinished work will be discussed, and also other examples of simple brushwork where colour was not used, and probably never intended. Some religious papyri, for example, were illustrated in line alone, occasionally with just a touch of red to set off the black, the scribe quite clearly contenting himself with the two basic colours of the scribal palette. This chapter is, in a sense therefore, an interlude in which we may be reminded of the importance of drawing to all art, and particularly to Egyptian art.

A few examples from unfinished standing monuments may serve to introduce what may be seen of pure line in the British Museum. A most accomplished series of drawings of funerary offerings adorns the walls of the burial chamber of the tomb of Mereruka, a vizir of the early Sixth Dynasty (c.2320 BC), at Saqqara. The drawing shows signs of correction and the wall in places still retains the guidelines marked in red. In the part illustrated here (fig 42) the delicacy and assurance of the line is astounding, proclaiming the work of a virtuoso artist. This, nevertheless, was preliminary, intended to be carved away. Why lavish such care and apply such finish? The answer lies not so much in pride of achievement, but in the fact that the artist must have known that if the tomb was left incomplete, his drawings would have to act in place of what was planned to be carved. Unfinished though they are, his drawings still very adequately

42 The offerings for the posthumous benefit of the vizir Mereruka are represented in fine line drawing on the wall of his burial chamber at Saqqara: cattle, fruit, vegetables, meat, bread, drink, and even flowers.

depict the offerings expected by Mereruka.

The tomb of Ramose, vizir under Amenophis III and, for a time, Akhenaten in the Eighteenth Dynasty (*c.*1375 BC) is of unusual interest among the tombs of the Theban Necropolis in having fine painted scenes, carved low relief work of the most exquisite quality, work in the style of the high Eighteenth Dynasty and in the somewhat eccentric style of Akhenaten's reign, and also unfinished reliefs and preliminary drawings. The west wall of the main chamber is of particular interest here. The scenes on both sides of the

door-way leading into the undecorated inner chamber are in varying stages of completion. On the left side, there is a series of figures of Ramose presenting bouquets to Akhenaten, who is here called Amenophis (IV), his name before he changed it to that by which he is better known. The figures of the vizir are drawn on the prepared limestone surface within a clearly visible red grid, and the preliminary carving has started (*fig.* 43). In style the drawing, which is splendidly assured, is distinctly of the high Eighteenth Dynasty.

On the right side of the doorway, the

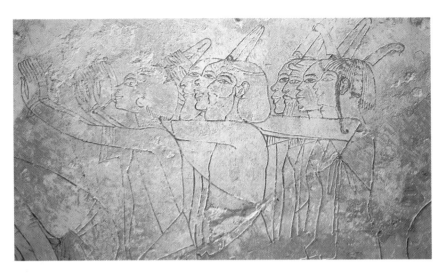

44 The heads of foreign emissaries prostrating before King Akhenaten in the tomb of Ramose at Thebes.

45 The burial-deity, jackal-headed Anubis, embraces King Amenophis II, a scene on a pillar in the burial chamber of the king at Thebes.

corresponding scenes are altogether different in content and conception, and the style is that which is associated with the reign of Akhenaten. The revolution in religion was accompanied by one in artistic representation; the new art is generally described as being more fluid and truer to nature, although often encompassing work of poor quality sometimes verging on caricature. The scenes in Ramose's tomb executed in the new style are mostly without the extreme gaucheries which were not uncommon in the reliefs carved for the temples built at Karnak by Akhenaten and Nefertiti. All this Theban work done in the early years of the new reign was transitional, hasty, and in some cases tentative. The scenes of this time in Ramose's tomb, however, are confident, masterly, and of the highest quality. Particularly striking is a group of foreign emissaries, Nubians, Syrians and a Libyan, whose figures are sketched out, but untouched by the carver's chisel (*fig.* 44). The heads are individual, racially distinctive, wonderfully composed as a group, and drawn with complete assurance. It is interesting and instructive to compare the work on the two sides of this wall. It is not unlikely that the draughtsmen working on the earlier, more conventional scenes, were those who were later obliged to modify their style in order to compose and draw the later scenes. Did they simply carry out the new work following careful designs prepared by others already tutored in the new style? Or did they themselves prepare the new designs after careful briefing? Sadly we shall never know. But we do know that the new work from the point of view of pure drawing was quite as skilled and sensitive as the old.

Many royal tombs in the Valley of the Kings were far from being finished when their intended occupants died. The quantity of decoration and inscription required to render a royal tomb effective as a proper home for the

46 A large limestone flake or ostracon inscribed with a royal scene showing Ramesses IX in a kiosk, approached by two men, identified by their dress and accoutrements as the crown prince and the vizir. Height 48.5 cm (no.5620).

required. In other respects, however, the tomb of Amenophis II shows many signs of incompletion, and one must suppose that this masterpiece of drawing was originally destined to disappear beneath the carver's chisel.

The steps by which the decoration for the walls of tomb or temple might be prepared remain uncertain, although – a suggestion made earlier – it may be assumed that some form of scheme was probably prepared on board or papyrus. The sketching out of important standard pictorial themes with accompanying inscriptions formed part, no doubt, of the training of outline scribes. It may be imagined that a student might be sent to look at the reliefs in a royal temple, for example, special permission perhaps having first been obtained from the appropriate high priest or his representative, so that a restricted area could be entered. Sketches might be made, adapted possibly for another king and another temple.

A large limestone flake in the British Museum may be the result of such an exercise (no. 5620, *fig.* 46). It shows King Ramesses IX of the Twentieth Dynasty (*c.*1130 BC) gesturing towards two fan-bearing men. It was pointed out long ago that the theme and essential features of this drawing, including the inscription to some extent, parallel a well-preserved scene in the mortuary temple of Ramesses III at Medinet Habu, carved about forty years earlier, and another in the same king's temple within the Karnak precinct. This drawing is not a careful copy of the known monumental examples, although it could have been based on a similar scene no longer in existence. The Medinet Habu version contains a second vizir; it is also noticeable, indeed remarkable, that the subordinate personages on the flake are almost as tall as the king, while at Medinet Habu the king towers over them at twice their height. Nevertheless, there is a conventional formality about the drawing

dead king was considerably more extensive than that needed for the tomb of a noble of even the highest position. In fact all royal tombs have uncompleted parts in the sense that not all are carved and painted in the final state which would have been considered desirable. Many scenes are half-carved, or left in outline only, complete in intention if not in execution. In the tomb of King Amenophis II of the Eighteenth Dynasty (*c.*1425 BC) all the principal decoration remains in line, colour being found only on the ceiling, the block borders and sparingly elsewhere. The pillars in the sarcophagus chamber carry the most splendid series of scenes showing the king receiving life in the form of the *ankh* from various deities. In *fig.* 45 for example, the scene is in line of the finest quality, utterly confident and at the same time sensuous and fluid. It would be good to think that when this drawn scheme of decoration was completed, it was seen to be such an accomplished achievement that no further work was felt to be

which extends to the hieroglyphic texts. This then is no casual sketch. It has been scrupulously prepared and there are red traces of guidelines and preliminary drawing. Yet it cannot be a working drawing, the actual design for a scene never perhaps carried out at full size. It must surely be some kind of trial or test drawing.

Limestone flakes, or ostraca, as they are commonly described (along with inscribed pottery sherds) by Egyptologists, were regularly used by ancient Egyptians for occasional writings and drawings. They have been found in great numbers in Thebes, where the limestone of the hills yielded smooth, handy, chips, ideal for informal use. The large flake just described is exceptional in its size and weight (it measures approximately 48 by 76 cm), the more usual size being rarely more than about 20 by 15 cm. The workmen of the royal gang in the village of Deir el-Medina were particularly inclined to sketch casually on ostraca. In some cases the drawings are formal and conventional, like the royal scene just described. More commonly, however, they are informal, sketched in a free and unbuttoned manner, suggesting both by their style of execution and by their subject-matter that the artist drew them for pleasure.

Sometimes the theme is one found regularly among the repertoire of scenes in private tombs; sometimes the drawing is accompanied by short inscriptions and may serve as a somewhat informal votive offering to one of the deities patronised by the villagers (no. 8508). Often the drawings are in effect caricatures, exhibiting the distortions and exaggerations which are commonplace in the products of this genre. But almost always the artist/draughtsman, untrammelled by the restraints which controlled his official work, draws with freedom and great spirit. He cannot wholly free himself of his years of training, and the essential conventions of

47 In the upper scene, a woman, almost nude, sits in a vine arbour, suckling a child. The vines seem to extend into the lower scene where a young girl engages in her toilet. Height 16.5 cm (no.8506).

48 *right.* A king offers a libation – a quick sketch in red paint on a limestone ostracon. Height 31 cm (no.50710).

Egyptian art remain observed – they represent after all how the ancient Egyptian looked at and saw the natural world – yet in these drawings he is free to express his artistic talents without having to keep constantly in mind the demands of his masters.

Two scenes on one small ostracon show women engaged in activities not commonly found in formal art (no. 8506, *fig.* 47). Both are executed boldly. On the upper part is shown a woman, scantily dressed, with an elaborate head-dress seated on a stool and suckling a child. In the lower scene, only part of which is preserved, a girl, her hair arranged

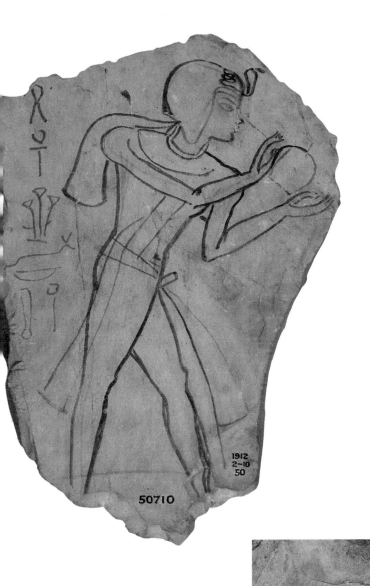

in widely spaced strands with a top-knot, prepares her toilet; in one hand she holds a mirror, and in the other an eye-paint tube from which protrudes the eye-paint rod or applicator. Many of the details are exaggerated in both scenes, and the face of the girl below is splendidly grotesque.

A more conventional subject shows the king bending forward, offering a vessel – an act of ritual libation (no. 50710, *fig.* 48). Drawn rapidly with bold strokes in red paint, this sketch characterises the confident skill of the Egyptian artist. Why such a drawing should have been made is a matter of pure speculation. It would be most unreasonable to consider it simply as a work of momentary spirit, dashed off with enthusiasm, perhaps to demonstrate the artist's skill with the brush. Many drawings on ostraca convey this feeling of immediacy. 'Look what I can do!', exlaims the artist. In a few lines he sketches a conventional subject, perhaps in grotesque or caricatured manner; then throws away the flake to lie undisturbed for three thousand years.

Many of these casual drawings are little more than doodles; but the doodle of a skilled draughtsman contains often the essence of his art. One flake of limestone bears a donkey's head which encapsulates the appealing charm of that animal (no. 64395, *fig.* 49); two jackals are sketched with complete assurance in a few bold lines (no. 43480); a lion head and a number of chicks casually fill the space of another flake (no. 26706); a cock is sketched with strong thick strokes (no. 68539). A common theme among these drawings on ostraca is that of animal caricature; animals are shown engaged in activities normally carried out by humans in tomb scenes. In such playful vignettes the artist allowed his fancy to improvise. In the British Museum the best examples of these animal drawings, often termed satirical, are to be found not on ostraca but on a papyrus discussed in the next chapter

49 Casual drawing of the head of a donkey on an ostracon from Thebes. It catches most economically the patient fortitude of the beast. Height 17.5 cm (no.64395).

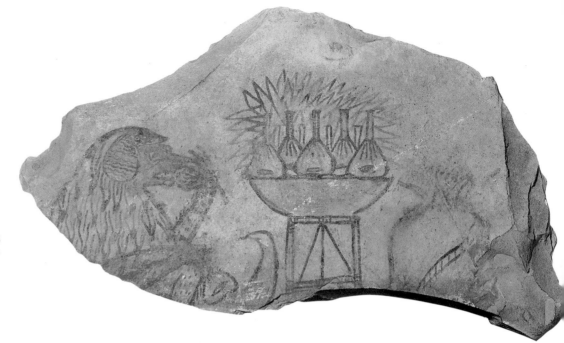

50 A drawing in black, heightened with some red wash, showing a baboon eating figs from a bowl standing on an offering-table. Height 10.5 cm (no.8507).

51 A bull drawn apparently to no purpose among various jottings on the reverse of a papyrus (no.10184).

(p. 60, *figs* 69, 70). A good representative ostracon drawing, however, shows a baboon seated by an open-work table holding a bowl of figs and lettuces; the animal eats one of the figs. The drawing here is unusually fine and precise for such a casual piece (no. 8507, *fig.* 50).

Egyptian artists were particularly skilful in depicting animals, birds and other creatures of the natural world, and it is certainly true that the drawing of animals did evince the most appealing work from these artists. Given a suitable space and the opportunity to sketch freely, the Egyptian artist would, as likely as not, draw an animal or bird, or a group of creatures behaving in the most naturally human way. Even on papyrus the casual sketch might intrude among memoranda and jottings. A fine bull is drawn, not wholly incongruously, among such occasional notes on the reverse of a papyrus (no. 10184, sheet 4, *fig.* 51). It appears there as if the scribe had suddenly become bored with his regular work

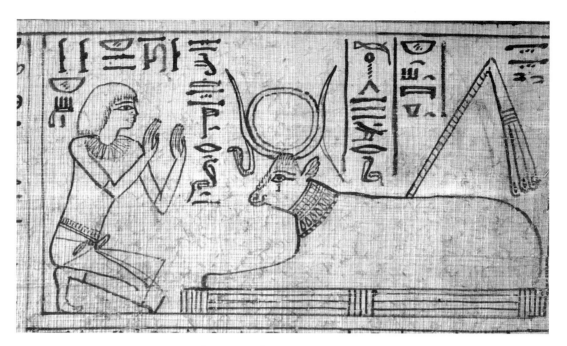

52 The divine cow Mehet-weret, personification of the primeval flood, is worshipped by the scribe Nebseny; a vignette from Nebseny's copy of the *Book of the Dead* (no.9900, sheet 16).

and saw just the right space for a quick drawing. 'I too might have been an outline scribe', he may have thought.

But simple line drawing on papyrus was also used for more serious matters. Religious papyri were regularly illuminated with vignettes illustrating the various sections, chapters, or spells. From the Eighteenth Dynasty such vignettes were mostly coloured, and they will be discussed in the next chapter. Occasionally, however, papyri were illustrated by line alone and in these can be observed some of the very finest specimens of controlled draughtsmanship. From the many good examples in the British Museum, three papyri from different periods may be taken as representative.

The first is the *Book of the Dead* of the scribe Nebseny (no. 9900), written in the mid-Eighteenth Dynasty (*c.*1450 BC). It is a very well written document, over 23 metres in length, illustrated rather sparingly with line drawings, in the manner of the early copies of this funerary compilation. The drawings are carefully executed in the precise style already observed in the tomb paintings of the same period (p. 23). Here the work is economical, uncluttered with detail, and very assured. The quality is well observed in a small vignette (15 × 8 cm) which shows Nebseny kneeling in adoration of the cow deity Mehet-weret. This simple scene is drawn with great delicacy, and demonstrates the masterly control exercised by the artist in using his primitive brush to produce lines of varying thicknesses to emphasise outlines and to mark fine detail (*fig.* 52).

Very different in scale and execution is the Greenfield Papyrus (no. 10554) which contains the text of the *Book of the Dead* prepared for the burial of the high-born priestess Nesitanebtashru, the daughter of the High-priest of Amun, Pinudjem I, during the Twenty-first Dynasty (*c.*1025 BC). It is in several respects one of the most magnificent documents to have been preserved from antiq-

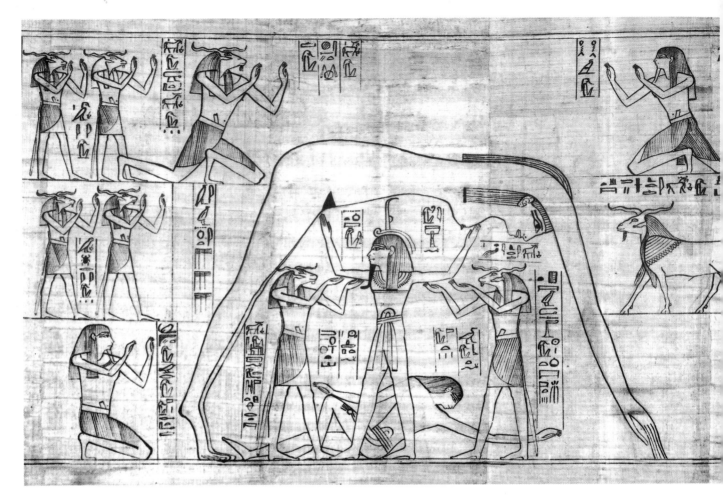

53 The creation of the world by the separation of heaven (the goddess Nut, as a naked woman) from the embrace of earth (the god Geb, prostrate on the ground). Shu, the sky-god supports heaven on his hands (no.10554, sheet 87).

uity. The original roll (it is now cut into 96 sheets placed between glass) was over 37m long, the width being 47cm. It is lavishly illustrated throughout with appropriate vign-ettes, most of which occupy the upper quarter of the space contained between the lines enclosing the inscribed area of the papyrus. Some illustrations, because of their nature, require a larger scale, and these may occupy the full height between the boundary lines.

The most famous of these large vignettes illustrates an important mythological event in the formation of the world, according to the

cosmogony of the ancient Egyptians (fig. 53) Here is the sky, the goddess Nut, shown as a naked woman, her arched body representing the vault of heaven; her feet touch earth on the eastern horizon and her fingers on the western horizon. By night, when it is dark, she em-braces Geb, the earth-god; but when it is light the two are separated by Shu, the god of air The excellence of the drawing of this vignette needs no words to commend it; while the composition as a whole far surpasses what was commonly shown in the generality o similar scenes. The papyrus here and in many

other places still bears visible traces of the red preliminary drawings over which the skilled draughtsman superimposed his own bold black lines. There are no signs of hesitation or uncertainty in the long sweep of the outlines of the principal figures. In spite of the distortions of scale and proportion determined by the nature of the representation, no sense of unbalance or of the grotesque intervenes to upset the over-all rhythm of the composition.

This vignette comes towards the end of the great Greenfield scroll. Much nearer the beginning is a series of drawings at the smaller, more common, scale, illustrating the funeral procession to the tomb of Nesitaneb-tashru. The events are set out in two narrow registers (fig. 54): above are the final rites before the placing of the body in the tomb. Offerings are made, prayers read, and mourners wail. In the lower register further offerings are made and furniture for the tomb is brought; a calf stands by its mother having already had one of its legs cut off – a regular detail in such scenes. The elements of these scenes, although drawn to a much smaller scale than those of the Nut scene described above, are executed with equal skill and assurance, and with a much finer line. How could the artist control his primitive brush with such consistent effect?

For control of primitive implements, however, no papyrus in the British Museum collections presents better evidence than the *Book of the Dead* inscribed for a man named Ankhwahibre (no. 10558). It has been dated as late as the first century BC or even the first century AD, but the nature and style of the illustrations point very strongly to an earlier date, possibly fifth to fourth century BC. The representations in the vignettes show none of

54 Part of the funeral vignette in the *Book of the Dead* of Nesitanebtashru. Her mummy is shown placed before her tomb while the last rites are performed (no. 10554, sheet 2).

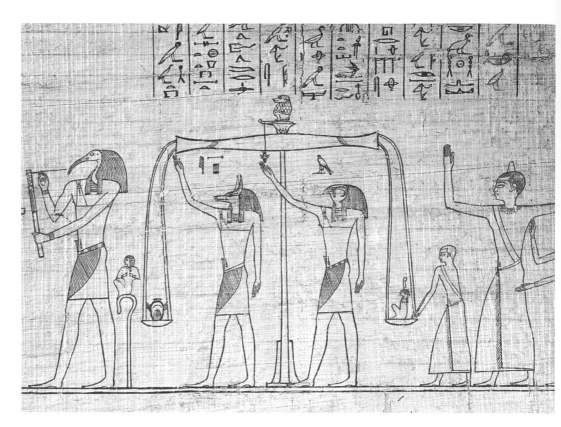

55 Ankhwahibre's heart is weighed against Truth in the judgement before the dead person is proclaimed 'true of voice' and conducted to Osiris (no. 10558, sheet 18).

the Greek influence which so commonly can be detected in Egyptian art after the conquest of Alexander in the late fourth century. The drawings also show every sign of having been executed with the brush, and not with the pen of split reed which became a common scribal implement after the same date. The outstanding feature of the drawings in this papyrus is the minute exactitude of the detail. Most of the vignettes are confined within narrow registers at the top of the papyrus, with human figures frequently not exceeding 2cm in height. In the illustrated example the scale is greater; but being so it provides a better opportunity to observe the skill of the draughtsman. Part of the judgement of the soul of Ankhwahibre is shown (*fig. 55*). A balance is set up to weigh the deceased's heart against truth (Maat). The

balance is checked by jackal-headed Anubis and falcon-headed Horus. The plumb-bob which Horus steadies, is watched over by Thoth as a squatting baboon (8mm high). Wherever detail is required it is added in the finest of lines with no wavering or uncertainty. Here is admirable testimony of the persistence of a tradition of skilled craftsmanship long after the time when conventionally the Egyptians are said to have slid into irreversible decline from an artistic point of view. This is not what is generally thought to be characteristic Late Dynastic or Graeco-Roman art. As pure draughtsmanship it is the equal of any earlier work. But one cannot deny that here it lacks originality and vitality. The skill is traditional and of the highest order; the effect is conventional and static.

5
Illuminated papyri

Much is made of the religious, even funerary nature of the legacy of material preserved from ancient Egypt. Mummies, coffins, tombs and temples occupy the centre of the popular conception of Egyptian culture. It is partly the result of survival; tombs and temples were built for ever and the objects placed in tombs – the source of most museum material – were the eternal property of the deceased, to last also for ever. But there is no doubting the deep religious character of ancient Egyptian life and the best efforts of artists were clearly devoted to the making of objects and the preparation of paintings and reliefs destined for religious and funerary buildings. What might be made for earthly use was in the truest sense ephemeral, and only chance has preserved from antiquity the tantalising fragments of domestic life, including paintings, which provided the setting for the mundane activities of men and women at all levels of society. The same can be said for the cultures of most ancient and medieval societies.

In the consideration of illustrated manuscripts the religious predominance is manifest, whether we consider medieval illumination or ancient Egyptian religious papyri. The latter are, however, particular in one important respect: they were made for eternity, but only for the eternity of one person, him or her who was named within the document; they were to be seen and consulted only by that one person. In fact, once placed in the tomb a copy of the *Book of the Dead*, for example, would never be seen by living man again. What an incentive for the artist! Yet, as we shall see, this prospect of instant oblivion (as it seems to us) served as no clear obstacle to the production of well-designed, finely painted, work, inspired by the implications of the subject matter, and executed with full artistic dedication. For this chapter examples will be drawn exclusively from the very rich papyrus collection in the British Museum; almost all are evidently re-ligious and funerary in character, vignettes from copies of the *Book of the Dead* and similar compilations. A very few non-funerary illuminated papyri are also included, but even here the illustrations are religious, or religiously inspired.

The nature of the texts requiring illustration was for the most part wholly funerary and the vignettes were strictly appropriate to the various parts of these texts, although they were not always included in the right places in the copies supplied. The principal purpose of the *Book of the Dead* and other funerary texts was to enable the owner, the deceased, to achieve his proper, posthumous existence. Much more information and a wealth of illustrations from the Museum's papyri can be found in R.O. Faulkner's, *The Book of the Dead* (British Museum Publications, 1985). The examples chosen for illustration here demonstrate principally artistic skills, not ritual intentions, although the latter may occasionally require a minimum of explanation.

In the Eighteenth Dynasty arose the practise of including funerary texts on papyrus rolls in the burials of non-royal people of suitable position, both men and women. Most of the best of the Museum's illuminated copies of the *Book of the Dead* come, however, from the post-Amarna period, the late Eighteenth and early Nineteenth Dynasty, and their illustrations show in many cases a conservative approach which links them, in matters of artistic style, to the period of high Eighteenth-Dynasty mural painting of the pre-Amarna period. The first example to be illustrated, from the *Book of the Dead* of the scribe Userhat (no. 10009, *fig.* 56) may be placed in the pre-Amarna period (reigns of Amenophis II to Amenophis III, *c.*1450–1379 BC), although there remains some uncertainty about this dating. The painting has a certain primitive quality (certainly not apparent in the best tomb-painting of this time) which may indicate an early essay

in papyrus illumination. The vignette shows a version of the worship of the sun-god at his time of rising by four baboons who raise their hands up to the deity shown as the sun's disc from which a pair of long arms with open hands stretch down. The sun appears beneath a wide pair of graphic symbols representing the sky (⚊) and the desert horizon (◡); it is the moment of rising when the sun may be seen to rest in the fold between two hills in the eastern horizon (◠). The conception of this theme, reproduced with striking variations in many other papyri (*fig.* 66 shows a later example of Twentieth-

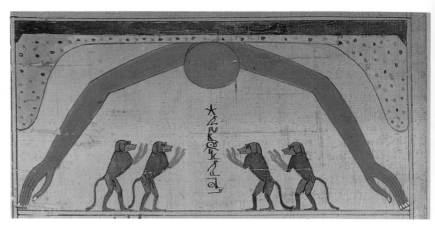

56 Baboons raise their paws in adoration of the rising sun, the god Re, who embraces the earth with outstretched arms (no.10009, sheet 1).

57 Nakhte and his wife Tjuiu leave their house in the early morning to greet the rising sun, and also the god Osiris. The latter is shown attended by Maat, raised high on a dais (no.10471, sheet 21).

58 The scribe Nakhte paddles his boat, makes offerings to the divine scribe Thoth, adores the phoenix and harvests flax, all scenes from the vignette showing Nakhte in the after-life (no.10471, sheet 13).

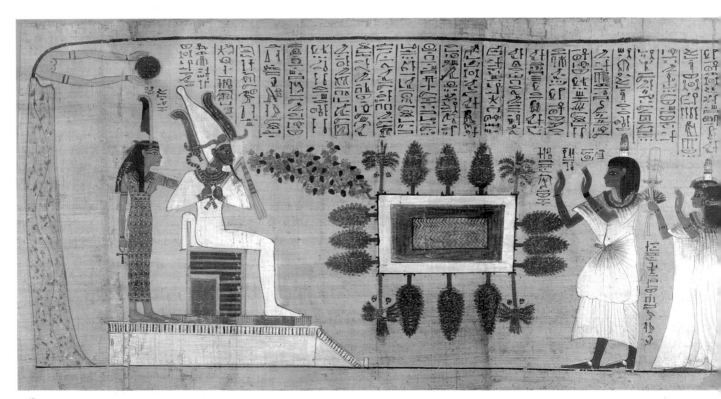

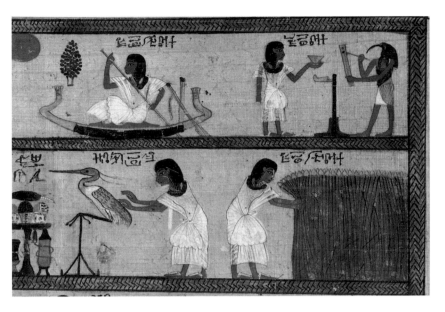

Dynasty date), is simple, even a little gauche, but its simplicity and flat use of colour give it an appeal often to be found in Egyptian art of moderate quality.

Three of the finest copies of the *Book of the Dead* in the British Museum date most probably from the early decades of the Nineteenth Dynasty (*c.*1320–1290 BC). Nakhte, the posthumous owner of the first (no. 10471), was a royal scribe and military commander. His copy includes one unusual scene in which Nakhte and his wife Tjuiu are shown leaving their house at dawn to adore the rising sun-god Re, as the text declares, but also Osiris seated on a throne supported by the goddess Maat 'mistress of the Two Lands, daughter of Re'. Here is an unusually well composed painting, conceived linearly, but strangely made coherent by the centrally placed garden pool (*fig.* 57). Elegance and a subtle use of shading in the painting of the garments worn by Nakhte and Tjuiu, distinguish the artist of this papyrus. There is also unusual inventiveness in the realisation of some of the conven-

tional elements: the arms of the goddess Nut, divine personification of heaven, which hold out the newly risen sun, seem to emerge from the desert hill, here shown as a sweeping downward sandy cascade. The sinuous movement of the sand is emphasised by fine red undulating lines drawn down the length of the 'hills'. The representation of the pool here differs in one important respect from that in the painting from the tomb of Nebamun discussed earlier (*fig.* 28, and p. 29) the trees around Nakhte's pool are all shown growing away at right angles from the verges. An imaginative and unusual detail, however, is the vine, heavy with grapes, which is depicted growing from the corner of the pool to the face of Osiris, not only god of the after-life but god of fertility.

Most of the vignettes in Nakhte's papyrus are small and confined to a register running above the text. One series, occupying the whole height of the document shows Nakhte engaged in those activities, mostly agricultural, which were thought to be typical of life in the hereafter, the so-called Field of Reeds. Along the waterways of this eternal country the blessed deceased might hope to travel in a boat when not ploughing and reaping. Nakhte paddles himself along squatting easily in his papyrus-boat – a vignette of the greatest charm (*fig.* 58).

The brilliance of the colour used by the artist who illuminated Nakhte's papyrus, is surpassed by that provided by the palette of the vignette-painter of the royal scribe and steward, Hunefer or Herunefer (no. 9901). This artist, who in some respects neglected the precisions of his training, possessed considerable imagination and a fine feeling for the disposition of figures in a conventional scene. Among such scenes commonly found in illustrated funerary papyri were the judgement of the deceased and the funeral procession to the tomb. In Hunefer's judgement (*fig.* 59) the

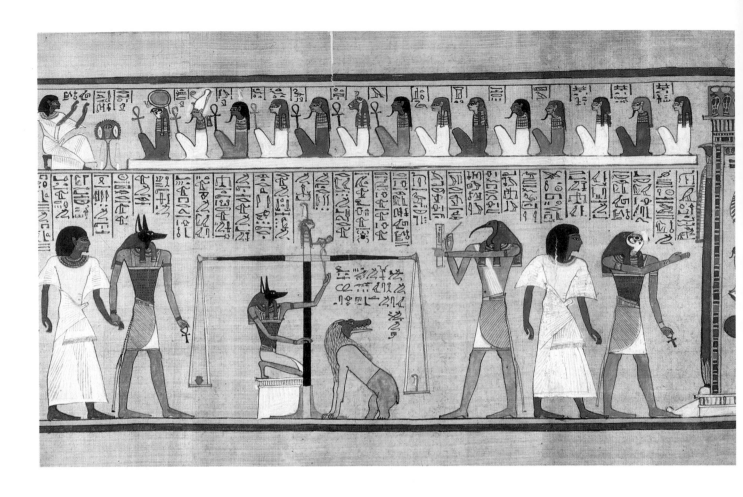

59 Hunefer is brought to judgement by Anubis, is judged, and then led into the presence of Osiris by falcon-headed Horus. The panel of judges is shown at the top (no.9901, sheet 3).

usual actors are shown: jackal-headed Anubis steadies the plumb-bob of the balance where Hunefer's heart is weighed against the feather of Truth; ibis-headed Thoth notes down the correct answers; the 'Heart-eater', the strange creature with crocodile head, lion forequarters and hippopotamus hindquarters, looks wistfully after Hunefer as he is led away to Osiris by falcon-headed Horus after passing his examination. Colour is used in a very straightforward manner, but one may specially note the very successful indication of flesh beneath the white garments of Hunefer by the subtle application of pink; the robes clearly are made

of the finest, almost transparent, lawn.

For successful composition, however, there are few vignettes in funerary papyri to compare with the scene of priests and mourners at the entrance to Hunefer's tomb (*fig.* 60). Hunefer's mummy supported by a jackal-headed priest, has its mouth and other orifices opened by a priest holding special implements, and accompanied by another who offers some liquid from a jar four times (the jar is shown as four jars). Behind stands the priest in charge, wearing a leopard skin and offering incense and a libation. Two bare breasted ladies, one of whom is Hunefer's wife, Nesha, mourn at the

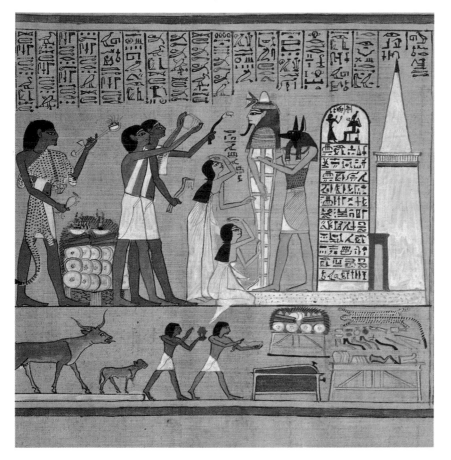

60 Hunefer's mummy is brought to his tomb which here is marked by a superstructure topped by a pyramid and an inscription containing an offering-text on Hunefer's behalf (no.9901, sheet 5).

feet of the mummy. Although this final scene in the burial of Hunefer is but the last event of a series, depicted in linear form, as was common in Egyptian art, it can as here be isolated to form a very satisfactory vignette on its own. Again it is the positioning of the figures and the grace with which they are drawn which claim attention, but the colour is not obtrusive. As we have observed in the consideration of tomb painting, the two priests engaged principally in the ceremonies have their bodies distinguished by different shades of brown paint. A further nice touch is the drooping fold of cloth from the kneeling

mourner's garment, which is allowed to hang below the base-line of the scene.

In considering the illustrations in the third of the great early Nineteenth-Dynasty papyri, that prepared for Ani, who is given the title 'king's scribe', some note should be taken of the extraordinary disparity between the written text and the illumination. While the quantity, quality and subtlety of the vignettes are unparalleled among Books of the Dead, the text is full of errors. (no. 10470). How could such a wondrous body of painting have been included in what may otherwise be considered a very indifferent document? For present purposes, however, illustration is what requires consideration, and a start may be made by drawing from the funeral scene in this papyrus a group of bare breasted female mourners accompanying the cortège to Ani's tomb (fig. 61). They are arranged to form a truncated triangle, the individuals turned in different directions to give an impression of constant movement. Each figure, by itself, is not remarkable in attitude or execution, but the artist by disposition and small variations of pose has created a quite remarkable presentation of abandoned grief.

Of the great set-piece illustrations which dignify this papyrus, none is better known than the judgement of Ani with the weighing of his heart. It is followed by the presentation of Ani to Osiris (fig. 62). In this richly ornamented scene Ani is shown squatting with one raised knee on a reed mat paying homage to Osiris seated in a shrine and supported by the goddesses Isis and Nephthys. The profusion of funerary offerings in front of and above Ani, and the architectural complexities of the god's shrine have given the artist opportunities for elaborate and detailed decoration which he has exploited to the full. He is, nevertheless, a master of muted, almost sombre colour; his palette is rich in browns and greens; it is autumnal in a sense, and this effect is enhanc-

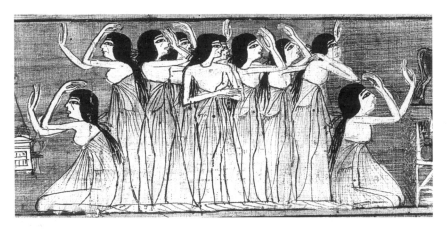

61 Mourning women accompany the dead scribe Ani on his journey to the tomb. Some cast dust on their heads as a sign of grief (no. 10470, sheet 6).

62 After his judgement, Ani has been brought to Osiris, and kneels in humility before the god of the Underworld. As usual the god is shown in the form of a mummy, for he was the embodiment of the dead (no. 10470, sheet 4).

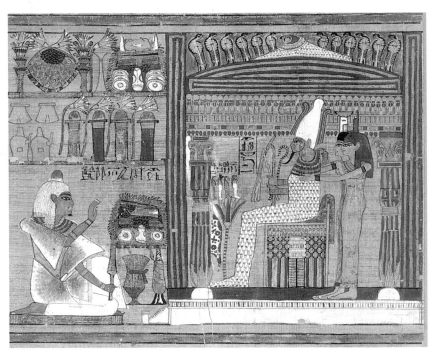

ed, accidentally, by the rich brown colour of the actual papyrus. Of the many striking elements in this scene consider just the figure of Ani; the broad sweeps of his garment introducing movement where all is in fact in repose; the dress itself is wonderfully coloured with deep reddish-brown shading into lighter brown at places where the pleating is close. In general, the artist's use of space and his actual draughtsmanship are remarkable. The one crowded element, unfortunately necessary for the scene as a whole, is the lotus flower in front of Osiris on which stand the four sons of Horus whose function was to protect the internal organs of the deceased after mummification.

Of the many smaller, individual vignettes which illuminate Ani's papyrus with such abundance, examine one which looks forward to Ani's life in the hereafter and one which presents a mythological symbol of time past and future. The first (*fig. 63*) shows Ani and his wife Tutu seated together in a reed kiosk playing *senet*, a board-game which has erroneously been described as a form of chess. Graphically this scene demonstrates very clearly the difficulties which arise from the ancient Egyptian convention of placing events and individuals one after the other. Poor Tutu's left hand on Ani's shoulder is disastrously divorced from her own. Yet the scene conveys the informality and charm, characteristics which are absent from the second small vignette which shows two lions seated heraldically back to back (*fig. 64*). They are 'tomorrow' on the left and 'yesterday' on the right, and they support between their bodies the sun in the desert horizon of the east beneath the blue arch of the sky; the sun is 'today'. This not uncommon image is here carried out with the utmost skill; the tawny hue of the lions' bodies is subtlely shaded and delightfully relieved by the herringbone pattern in reddish-brown on the bellies and by the detailing of the manes in the same colour.

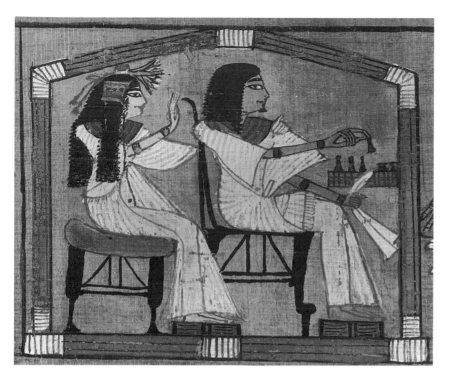

63 Ani plays *senet* with his wife Tutu. From the looks on their faces both seem to believe that Ani's next move will be to the advantage of each (no. 10470, sheet 7).

64 The lions of yesterday (right) and tomorrow (left) support the sun in the horizon, which is today (no. 10470, sheet 7).

They are not just docile creatures watching over the past and the future; the touch of red in their eyes warns of latent fury.

Fine medieval manuscripts are lavishly enriched in their illumination by gold. The metal set off brilliantly the rich colours used by the artists and rendered their productions more worthy and much more valuable. It is perhaps not surprising to find that gold was also used for illumination in ancient Egypt, although examples are few. Gold-leaf was used lavishly by Egyptian craftsmen for the embellishment of funerary furniture including coffins, but it does not seem to have formed a regular part of the equipment of the outline scribe. The few surviving examples of its use on papyrus may therefore be considered exceptional. The earliest in the British Museum is easy to explain. It occurs on a vignette in the *Book of the Dead* made for Neferronpet (no. 9940) in which the jewellery worn by the deceased owner and his wife is enriched with gold leaf (*fig.* 65). The vignette is very poorly preserved, but gold can be distinguished on head-bands, collars, armlets and on the sistrum held by his wife Hunro. Neferronpet carries the title 'chief of the makers of thin gold'; he was in fact a senior craftsman in charge of gold-beaters and therefore ideally placed to acquire some of the precious material made in his workshops. Laboratory examination has shown that this leaf was on an average 0.006 mm thick, but it was not possible to determine what adhesive, if any, was used to attach the gold to the surface of the papyrus.

Like most of the papyri discussed so far, Neferronpet's *Book of the Dead* may be dated to the early Nineteenth Dynasty and its use of gold-leaf is the earliest so far identified. The next oldest in date also can be found on a British Museum papyrus (no. 10472), the *Book of the Dead* of Anhai, a singer priestess of Amun, who lived during the Twentieth Dynasty (*c.* 1150 BC). The gold enriches the

opening vignette. The theme is the adoration of the rising sun, examples of which we have already seen in papyri of earlier date (p. 52). Here the sun is addressed as Re-Harakhty (Re-Horus of the horizon) and is represented as the divine falcon on a perch (*fig. 66*). This interpretation of the theme so simply expressed elsewhere, is crowded with unconnected detail, much of which is rather mechanical. The liveliest elements are the adoring baboons who positively skip with pleasure as they greet the morning sun. But the use of gold is what is specially to be noted. It is used on the sun's disc, the face of the falcon and on the leg feathers. Again the use of gold to embellish the sun's disc is easily explained, and, by extension, the gilding of parts of the bird. Its use, however, is restricted; no gold is found on any of the other vignettes in this papyrus. Laboratory measurement of the gold here showed it to be about 0.009 mm thick, somewhat thicker than that used on the papyrus of Neferronpet. The greenish tinge of the gold on this later example could not be explained.

Colour, as well as gold, is used sparingly in the illumination of this papyrus. The artist was an accomplished draughtsman and he relied principally on a very fine line reinforced in places by colour used with restraint. The figures of Anhai which occur at large scale in the principal vignettes are executed with great elegance. She is commonly shown (*fig. 67*) standing; her dress is uncoloured and its very existence is suggested simply by its outline and by rather faint red lines indicating pleats. Colour is almost confined to the head: she wears a multi-coloured collar and a similar band around her wig. A touch of red brings a blush to her cheek.

Dating from about the same time as Anhai's papyrus, is the longest of all known papyri, a document quite different from those so far considered. The Great Harris Papyrus (no. 9999) contains a comprehensive list of the

donations made by King Ramesses III of the Twentieth Dynasty (*c.*1198–1166 BC) to the temples throughout Egypt. It is a magnificent document, 41 cm in length, beautifully written by a master calligrapher, and illustrated in three places by splendid vignettes. Ramesses III is shown standing before the principal deities of Thebes, Heliopolis and Memphis, expounding all his benefactions. This papyrus was not funerary, but a record document, to be deposited in the State archives. It might therefore be consulted, and looked at in ways inconceivable for funerary texts. It was distinctly a royal document and the artist and the scribe (if they were not one and the same person) may be thought of as being among the finest available at the time. The subject matter of the three vignettes gave little scope for originality, but for the King at least figures of great majesty were produced. Ramesses addressing the deities of Heliopolis (*fig. 68*) is perhaps the grandest of the three royal repres-

65 Neferronpet and his wife in a scene of adoration in which details of ornament are embellished with gold leaf (no.9940, sheet 1).

67 The singer priestess Anhai stands in adoration, shaking her sistrum, the mark of her office, and holding a length of vine foliage (no.10472, sheet 7).

66 The rising sun is adored in the form of the falcon Re-Harakhty on a perch. The sun's disc on the god's head is gilded (no.10472, sheet 1).

67

66

68

68 King Ramesses III addresses the three gods of Heliopolis, expounding the benefactions and other honours he has made for them. Height of figure 31 cm (no.9999, sheet 24).

entations. The drawing of the figure has something of the slender elegance of Anhai's figure which we have just discussed. Perhaps the artists were trained in the same school. There is also in the Ramesses figure a restriction in the use of colour, although there is here greater scope for elaborate multicoloured accoutrements than on the figures of Anhai. Ramesses wears a white linen robe, the pleats of which are marked by red lines; its hem and edges are decorated either with added braiding

or with embroidcry. Unusually the King's exposed flesh is painted white, the stark appearance of the face relieved by the black-outlined eye and brow and the bright red lips; equally unusually, his 'white' crown is painted yellow. The Egyptian artist was ever prepared to change a canonical colour to achieve a good visual contrast. In this royal representation he has eschewed detail, concentrated on bold lines and produced a fine, although somewhat wooden, posthumous

69 A scene from the Satirical Papyrus, showing a lion and an antelope playing the *senet*-game. From the look of triumph on the lion's face, it appears that he is in a winning position (no.10016).

portrait of one of Egypt's great warrior monarchs.

The most appealing illustrated papyrus in the museum is also secular, although its subject matter has more than a slight connection with the scenes found in Theban private tombs. Here we have a precious reminder of the other side of Egyptian life, the ability to mock in this life the aspirations of the life hereafter as expressed in funerary art. The Satirical Papyrus, as it is called, shows creatures engaged in activities which belong to the repertory of tomb scenes (no. 10016). This mocking of what was essentially a very serious matter was a characteristic posture of the craftsmen who lived in the workmen's village of Deir el-Medina, and many of their discarded ostraca bear little vignettes of similar kind to those painted on this papyrus. Here are scenes we have met more formally elsewhere. A lion and an antelope sit down together to play *senet* (*fig.* 69) just as Ani and Tutu did (p. 57, *fig.* 63), although the two animals face each other and are not seated side

by side. Further along the papyrus to the right we find a cat herding geese (*fig.* 70), a reminder in part of the goose census in Nebamun's tomb (p. 31, *fig.* 30). The cat is supported by a fox holding a staff and carrying a bag slung on another stick across his shoulder. Although such disrespectful drawings are not very rare, there are few which have survived on the dignified medium of papyrus. The artist in his lack of respect has nevertheless painted delicious parodies of scenes which were the stock in trade of himself and his fellow tomb craftsmen. Yet there is no malice apparently here. The animals are shown in their quasi-human roles in an affectionate way, seriously engaged, delightfully and unsentimentally observed, the products of some ancient Louis Wain. What can there be incongruous about a cat herding geese?

During the Twenty-first Dynasty (*c.*1085–945 BC) exceptional attention was paid to burial practices, the direct result probably of the discovery of widespread tomb-robbing

70 A cat herds geese, and, on the right, part of a damaged scene showing a lion engaged apparently in rites of mummification on a dead donkey lying on a bed (no. 10016).

71 The high-priest of Amun, Pinudjem II, offers incense and water (damaged) to the god Osiris, shown as a mummy standing on a plinth (no.10793, sheet 1).

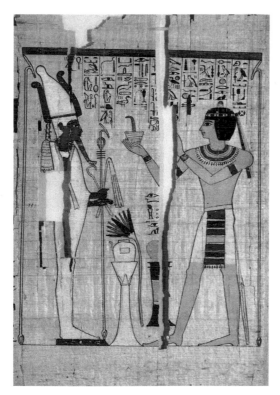

in the royal and noble necropolises at Thebes. Changes were introduced in methods of mummification and in the actual forms of burial. The papyri provided for the funerary equipment of important people also underwent modifications. While *Books of the Dead* were still provided, they were frequently illustrated only with one initial vignette. Many examples of this kind are to be found in the British Museum, a good specimen being the papyrus of the high-priest of Amun, Pinudjem II (no. 10793), a finely written document introduced by a very simple vignette which shows Pinudjem offering incense to Osiris (*fig.* 71). The drawing is competent, and the colouring careful, but the whole is unimaginative and beyond comparison with the remarkable productions of the New Kingdom. The decline in standards may be considered even more striking when the status of Pinudjem is compared with that of Ani: a high-priest and a scribe. Yet even at this time the skill of the draughtsman was still practised at a high level, as the *Book of the Dead* of

72 A much abbreviated judgement scene in which Nodjmet shown as a rather unstately suppliant confronts the divine scribe Thoth as a baboon, apparently sucking the end of his scribal brush. Nodjmet as a miniature female figure is weighed against truth (Maat) (no.10541).

Nesitanebtashru demonstrated, with its lavish series of vignettes in simple line drawing (pp. 48–9, figs 53, 54). The changes in practise and requirement seem to defy straightforward analysis. As far as the British Museum collection is concerned, the last lavishly illustrated *Book of the Dead* is that prepared for Herihor, high-priest of Amun and virtual ruler of Thebes at the end of the Twentieth and the beginning of the Twenty-first Dynasty, and for his wife Nodjmet (no. 10541). Parts of this papyrus are in the Louvre and in Munich, and the whole must have been a very impressive document. Brilliantly coloured vignettes occupy a substantial part of the surface area; they present a fine and opulent impression,

but already they lack the invention and virtuosity in the use of line and colour which are such distinctive features of the earlier funerary papyri (*fig. 72*).

Many of the illustrated papyri prepared for burials from the time of the Twenty-first Dynasty contain funerary compositions different from the *Book of the Dead*, and the vignettes illustrate themes not found in the religious papyri of the New Kingdom. Some papyri contain a miscellany of religious and magical tests; others provide copies of the *Book of what is in the Underworld*, a text previously reserved for royal use. The papyrus of Henttowy, a musician–priestess of Amun (no. 10018), contains well-painted vignettes including a scene which shows that the skill of the artist in providing non-royal illustrations for such texts was by no means lost (*fig. 73*). The sun in the eastern horizon is worshipped and greeted by a baboon apparently warming its forepaws in the new morning glow, while Henttowy, bare-breasted, prostrates herself in worship. Here the composition and execution are admirable and the scene contains detail which would not be thought unworthy of the best papyrus artists of the New Kingdom in the inventive application of colour to suggest the hairy skin of the baboon, the wild arrangement of Henttowy's locks, suggesting her precipitate falling into prostration.

In general, however, the standard of papyrus illumination declined steadily as the Pharaonic Period drew to a close. The existence of fine sculpture, well carved reliefs, and small objects of excellent craftsmanship, shows that the skills of the Egyptian artists and craftsmen were by no means exhausted. Yet the vignettes in religious papyri from the same period are poorly designed and miserably executed. That fine work was still possible is shown by the line vignettes of Ankhwahibre's *Book of the Dead* (p. 50, *fig. 55*) and by other monochrome work down to the Ptolemaic

73 The musician priestess Henttowy prostrates herself in adoration of the sun emerging from the desert horizon and containing the eye of Horus, the whole group making a rebus for the divine name Re-Harakhty, 'Re-Horus who is in the horizon' (no.10018, sheet 1).

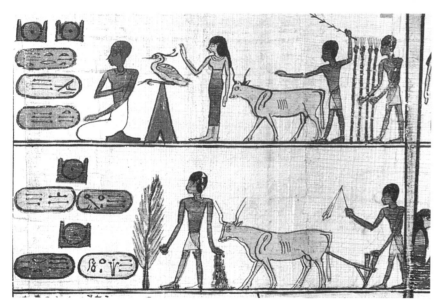

74 Hori ploughs, sows and gathers flax in the after-life. He deposits his seed in the ploughed furrow with complete insouciance and apparent lack of purpose (no.10479, sheet 7).

Period. Colour seems to have demoralised the artist. It was applied crudely and very little attempt was made to introduce detail and shading. The scene from the papyrus of Hori, probably of the fourth-third century BC (no. 10479), is among the more accomplished painted work of the period (*fig.* 74). Hori ploughs and sows in the Field of Reeds; the figures are meagre, the colour crude, while the detail shows clearly that the artist had little idea of what he painted; the plough is wholly misunderstood and would certainly not have done its job.

Some attempt to consider late painting in a positive manner, to find some merit in what is so clearly a travesty of the best in Egyptian painting, leads one to overrate the 'charm' of badly executed work, to find 'fresh' approaches to old themes in what is so certainly gauche and incompetent. But the attempt should be made. The papyrus of a certain Kerasher which probably dates from the end of the Ptolemaic Period or early Roman Period (50 BC–50 AD), contains texts of a late compilation called *Book of Breathings*, but illustrated with vignettes derived from the tradition of the *Book of the Dead* (no. 9995). The general impression is very striking, principally because the painting is dominated by an

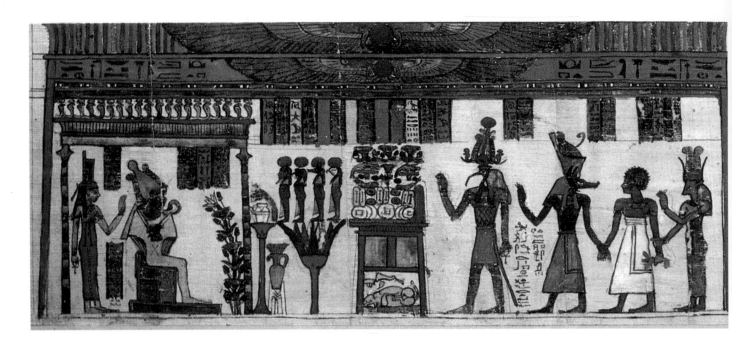

75 Kerasher is led into the presence of Osiris by Thoth and Anubis, who usually supervise the judgement of the deceased, and the goddess Hathor (no.9995, sheet I).

orange colour which is not part of the regular palette of Pharaonic artists. Close examination reveals most of the inadequacies common to painting in the period of decline, but there are some points of interest, even felicities, which emerge. Among the themes illustrated is the judgement of the deceased Kerasher. He is led before Osiris not by the conventional conductor, the falcon-headed Horus, but by a group of deities who seem to relish their unexpected elevation to this important function (*fig.* 75). The introduction is made by ibis-headed Thoth, and Kerasher is led forward by jackal-headed Anubis and cow-headed Hathor. There is some spirit in Anubis and a suitable placid charm in Hathor, but the surprise is Kerasher himself shown with an unusual curly head of hair (perhaps a wig). Something of Greek influence may be detected here, an influence found increasingly elsewhere in Egyptian art of the period. In time this influence would become dominant and the mummy portraits of the Faiyum, those most remarkable works of art, would owe little to the native tradition of graphic art, but most to that of the classical world.

6
Other forms of painting

In the introduction to this book attention was drawn to the abundant use of colour by the ancient Egyptians. A walk through the Egyptian galleries of the British Museum, or indeed of any other large Egyptian collection, emphasises the point. Apart from the tomb paintings and funerary papyri, a very large number of objects of stone and of wood, and of other materials to a lesser extent, are extensively painted, and the paint has survived in excellent condition in many cases. To complete this survey of Egyptian painting, a few examples have been selected to represent the multitude of other objects in different materials.

Sculptures of the lighter-coloured stones,

76 Katep and his wife Hetepheres sit together, a comfortable conjugal pair, her arm around him, and both shown at the same height–equality in eternity. Height 47.5 cm (no.1181).

especially limestone and sandstone, were commonly painted to add what was probably considered in antiquity a kind of verisimilitude, and also details of dress and ornament. Even granite, however, might have some paint added. The largest royal sculpture in the Museum, the great bust of Ramesses II (no. 19), has traces of red and yellow stripes on the headdress, still faintly discernible in the right light; the added paint when new must have made a striking effect. Of painted limestone sculptures, a good representative example is the charming pair-statue of Katep and Hetepheres, man and wife, seated side by side, of Old Kingdom date (no. 1181, *fig.* 76). According to convention the man's flesh is painted a reddish brown, while his wife's body is yellow; facial details are simply, but effectively, added in black.

In the decoration of tombs the preferred form of work was painted relief, flat, mural painting being used mostly when the stone of the tomb was unsuitable for carving. Paint applied to carved relief was by the nature of things, added embellishment to work which, if well done, could stand critical inspection without colour. But colour made a scene complete and there is no doubt that well-painted relief is very striking. Fragments from the tomb of the provincial governor Djehutihotpe, at Deir el-Bersha in Middle Egypt, dating from the mid-Twelfth Dynasty (*c.*1890–1860 BC), show a good use of colour to enhance relief by the addition of detail. The largest fragment shows a procession of men bearing a carrying-chair and various weapons (no. 1147). In the illustrated part of the scene (*fig.* 77), significant detail is indicated by colour; for example, the large shield is seen to be covered with leather, while the axe carried by the shield-bearer has a blade and a handle made of burnished copper, coloured yellow. Special note should also be taken of the very handsome painted hieroglyphs, the ap-

78

1368

1466

1908
4-11
50

1902
4-12
208.

78 The funerary stela of Sobkhotpe. At the top, he and his wife Djefu worship Osiris and Anubis, and in the middle register they receive offerings themselves from relatives. Height 58.5 cm (no.1368).

79 Stela of Penbuy, whose figure at the bottom right has in its painting close affinities with good New Kingdom papyrus illumination. The subject of Penbuy's adoration is Ptah of the listening ear. Height 38 cm (no.1466).

pearance of which is greatly improved by added internal detail.

On a different scale is the painted relief found on the funerary inscriptions or stelae which were placed in tombs from the Early Dynastic Period down to Roman times. Over such a long period (c.3100 BC–100 AD) styles varied greatly, and the actual uses of paint differed in purpose and degree. In some Old Kingdom tombs an attempt was made to suggest that the great, obligatory, limestone false-door stela was made of granite by painting it pink with spotted markings to suggest the multi-coloured texture of that stone. The huge stela of Ptahshepses in the Egyptian

Sculpture Gallery carries this pinkish-red paint, and its hieroglyphs are painted bluish-green to make them more readable (no. 682). Smaller stelae are sometimes painted in a careless manner; such is the stela of Sobkhotpe of mid-Eighteenth Dynasty date (no. 1368) on which the artist has applied his paints with a very casual attention to the carved outlines (*fig. 78*). More satisfactory is the small lime-stone stela of Penbuy, one of the craftsman-villagers of Deir el-Medina (no. 1466, *fig. 79*). Here great care has been taken to follow the lines of the relief, while the painting of the piled offerings on the table placed before the god Ptah is a riot of coloured detail.

66

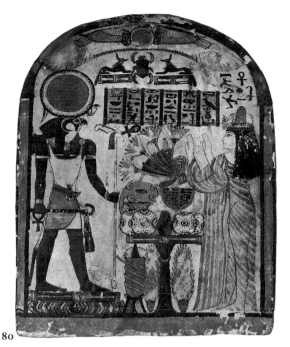

80 Deniu-en-Khons, a priestess, adores and makes elaborate offerings to the falcon-headed god Re-Harakhty, who carries, unusually, the regal crook and flail as well as the regular emblems, *ankh* (life) and *was* (power). Height 33 cm (no.27332).

77 Part of a scene painted on limestone showing weapon-bearers, from Djehutihotpe's tomb. The markings on the shield suggest it was covered with cow-hide. Height 36 cm (no.1147).

80

A similar vignette-quality can be found in the best of those funerary inscriptions made of wood in which painting is executed on an overlaid plaster surface. Wood was treated very sympathetically by the Egyptian craftsman, and, when painted, the surface was prepared in different ways depending on the quality of the wood. Poor wood was usually covered with a ground of gesso-plaster to provide a suitable surface for painting. Fine grained wood, like cedar, however, was spared this preparatory surface, and the painting might be executed directly on to the wood; it is not known if some colourless size or other dressing were first applied; no trace of such has ever been detected. The small funerary stela of the singer-priestess of Amon-Re, Deniu-en-Khons, falls into the category of gessoed wood (no. 27332), but its painting is of good quality for its period (*fig.* 80). It dates from the Late New Kingdom (*c*.1000 BC) and belongs stylisti-

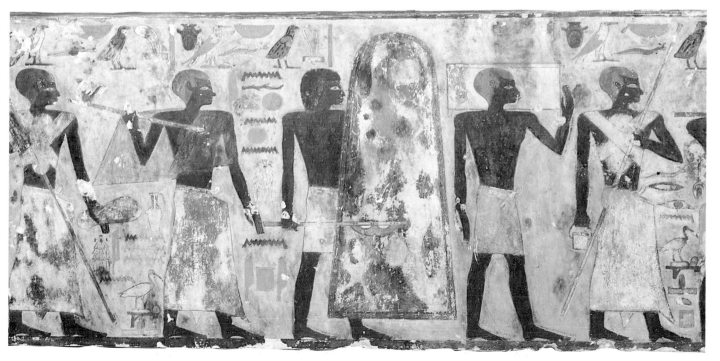

81 Detail of finely painted hieroglyphs on the cedar-wood coffin of Seni, from Deir el-Bersha. Tools, weapons, jewellery and articles of clothing are among the objects represented (no. 30841).

cally with those *Books of the Dead* which were mostly illustrated with only one initial vignette. The drawing is confident and the detail rich; there is an interesting variation in use between very fine lines and much bolder, sweeping, strokes of the brush where texture needs to be indicated.

Painting directly on to wood is found frequently on the great wooden coffins used for the burials of provincial nobles during the Middle Kingdom (*c*.2000–1750 BC). These coffins acted as the principal pieces of funerary equipment; they often were the vehicles for important funerary inscriptions and the depiction of items of food and drink, furniture, tools, weapons, amulets, clothing, needed by the deceased owners in their after-lives. The draughtsmanship is commonly very fine, and the colouring brilliant; as so often, the ancient designer of the painting on the interior and exterior of these coffins shows a masterly command of the use of the limited space

available. After all, the dead man, confined in his inner coffin within the great outer coffin (perhaps as much as 2.20 m long, 1.15 m wide and 1.20 m high) needed a well-planned, neatly decorated billet in which to pass his eternity. Fine examples in the British Museum display most of the best features of coffin painting of the Middle Kingdom. Almost the most satisfying elements, both aesthetically and decoratively, are the finely painted hieroglyphs which demonstrate to a high degree the special qualities of the Egyptian scripts when drawn with loving care (*fig.* 81).

Of the many different materials painted and inscribed by the ancient Egyptians none provided a less satisfactory medium for decoration than cloth; but painted and inscribed linen was used occasionally in funerary equipment from Predynastic times down to the Roman Period. Linen, unless it is of very fine texture, is difficult to paint on; it offers a poor surface for the brush, and it lacks rigidity so that through

82 A cloth painted with a scene in which six named ladies adore and present offerings to the goddess Hathor as a cow emerging from the western desert hills. Length 46 cm (no.43215).

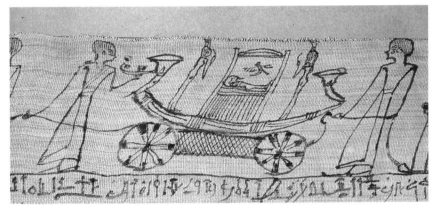

83 The mummy of Hor, in its barque, is conveyed to the tomb on a wheeled car. Movement in the cloth has produced distortions in the drawing (no.10265).

stretching and shrinking decoration may be distorted. A number of painted panels on linen from Deir el-Bahri, dating from the Eighteenth Dynasty, have vignettes of a funerary character. The largest of these (no. 43215) bears a scene in which at least six ladies (the last on the left is only partly preserved), adore the Hathor-cow emerging from the western mountains (*fig.* 82). This vignette demonstrates well the difficulties faced by the artist trying to paint in a conventional way on a somewhat coarse linen. Still he has managed with some success to reproduce on a poor

medium something which is recognisably Theban in the tradition of New Kingdom tomb paintings and illuminated papyri.

Linen strips were much used in place of papyrus in burials of the last four or five centuries BC. They include texts written in the hieratic script and vignettes mostly drawn with the pen which by this time had superseded the brush as the principal scribal implement. The drawings are much simplified and suffer greatly from the distortions common to work on cloth. They perpetuate the funerary tradition of illustrated texts, but they do little to continue the traditions of graphic skills which, however, were contemporaneously maintained in the line vignettes of some *Books of the Dead*. They, nevertheless, are not wholly without interest if only for the detail they contain. The linen *Book of the Dead* of the priest Hor (no. 10265), for example, contains a characteristic vignette of the procession to the tomb in which uncharacteristically the barque containing the mummy is drawn on a

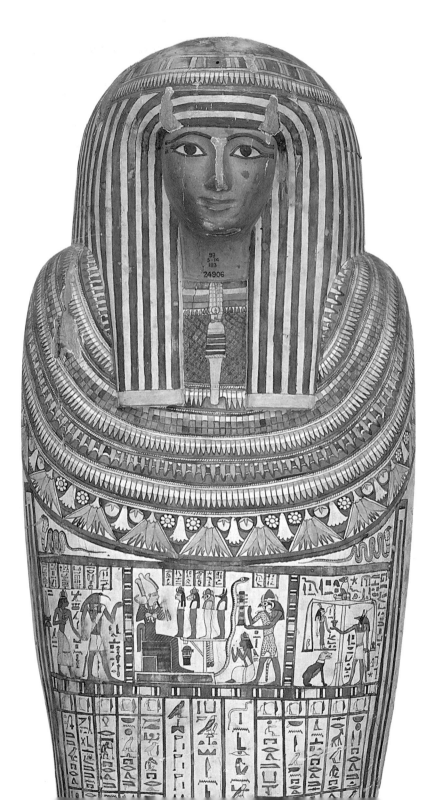

car with wheels (*fig. 83*).

A material incorporating linen which was extensively employed in the later centuries of the Pharaonic Period and in the Graeco–Roman Period is called cartonnage. It is a kind of ancient papiermâché, made from layers of linen stiffened with plaster, very suitable for the production of moulded objects, like inner coffins, and the masks placed over the heads of mummies. Cartonnage was a material well designed to receive paintings, and objects made of it were generously decorated. In the case of coffins, which were shaped to follow the form of the mummified body, the surfaces frequently carried texts and vignettes of the kinds found in the religious papyri. Like the great wooden coffins of the Middle Kingdom, mentioned above, they removed the necessity of having to take to the tomb some of the items previously required, or of having a tomb-chapel decorated with obligatory scenes. They provided self-contained homes for the bodies and the souls of the dead. (*fig. 84*).

This survey has in no way exhausted the wide range of paintings and painted objects in the Egyptian collections of the British Museum. Boxes, furniture, tomb-models, boats, cosmetic objects, and a host of other remarkable pieces provide eloquent testimony of the Egyptians' skills in painting and drawing. A visitor to the Egyptian galleries in the Museum may conduct a personal survey, and find many things not mentioned here. There are unexpected pleasures to discover: colour used in surprising ways; drawings of exceptional quality, paintings of rare subtlety. To look with discernment and with the expectation of revelation will bring many rewards.

84 Upper part of the cartonnage coffin of Pasenhor. The vignettes, like those on funerary papyri, show the judgment of Pasenhor and his entrance to the after-life. Height of coffin 203 cm (no.24906).

The Dynasties of Egypt

Early Dynastic Period
(DYNASTIES I-II)
First Dynasty
c. 3100–2890 BC
Second Dynasty
c. 2890–2686 BC

Old Kingdom
(DYNASTIES III-VIII)
Third Dynasty
c. 2686–2613 BC
Fourth Dynasty
c. 2613–2494 BC
Fifth Dynasty
c. 2494–2345 BC
Sixth Dynasty
c. 2345–2181 BC
Seventh Dynasty
c. 2181–2173 BC
Eighth Dynasty
c. 2173–2160 BC

First Intermediate Period
(DYNASTIES IX-X)
Ninth Dynasty
c. 2160–2130 BC
Tenth Dynasty
c. 2130–2040 BC

Middle Kingdom
(DYNASTIES XI-XII)
Eleventh Dynasty
c. 2133–1991 BC
Twelfth Dynasty
c. 1991–1786 BC

Second Intermediate Period
(DYNASTIES XIII-XVII)
Thirteenth Dynasty
c. 1786–1633 BC
Fourteenth Dynasty
c. 1786–1603 BC
Fifteenth Dynasty
(Hyksos)
c. 1674–1567 BC
Sixteenth Dynasty
c. 1684–1567 BC
Seventeenth Dynasty
c. 1650–1567 BC

New Kingdom
(DYNASTIES XVIII-XX)
Eighteenth Dynasty
c. 1567–1320 BC
Nineteenth Dynasty
c. 1320–1200 BC
Twentieth Dynasty
c. 1200–1085 BC

Late Dynastic Period
(DYNASTIES XXI-XXX)
Twenty-first Dynasty
c. 1085–945 BC
Twenty-second Dynasty
c. 945–715 BC
Twenty-third Dynasty
c. 818–715 BC
Twenty-fourth Dynasty
c. 727–715 BC
Twenty-fifth Dynasty
c. 747–656 BC
Twenty-sixth Dynasty
664–525 BC
Twenty-seventh Dynasty
525–404 BC
Twenty-eight Dynasty
404–399 BC
Twenty-ninth Dynasty
399–380 BC
Thirtieth Dynasty
380–343 BC

PERSIAN KINGS
343–332 BC

MACEDONIAN KINGS
332–305 BC

Graeco-Roman Period
after 305 BC
PTOLEMAIC KINGS
305–30 BC
ROMAN EMPERORS
after 30 BC

Short bibliography

C. ALDRED
Egyptian Art London, 1980

E. BRUNNER-TRAUT
Egyptian Artists' Sketches
Istanbul, 1979

N.M. DAVIES
Ancient Egyptian Paintings
3 vols, Chicago, 1936

T.G.H. JAMES
Introduction to Ancient Egypt
London, 1979

K. LANGE AND M. HIRMER
*Egypt: Architecture, Sculpture
and Painting in Three
Thousand Years* London,
1968

A. MEKHITARIAN
Egyptian Painting 2nd ed.
London, 1978

W.H. PECK AND J.G. ROSS
Drawings from Ancient Egypt
London, 1978

H. SCHÄFER
Principles of Egyptian Art
Oxford, 1974

W.S. SMITH
*The Art and Architecture of
Ancient Egypt* new ed.,
revised W.K. Simpson.
Harmondsworth, 1982

W.S. SMITH
*A History of Egyptian
Sculpture and Painting in the
Old Kingdom* London, 1946

Index to the collection numbers of the objects mentioned

NOTE: *Numbers in bold refer to illustrations*

NO.	PAGE
19	65
682	66
919	26
920	**25**
921	26
922	24
1147	65, 67
1181	65
1291	35
1329	34, **35**
1368	66
1466	66
1514	6
2292	8
5547	11
5601	13, **16**
5620	43
8506	44
8507	46
8508	44
9900	47
9901	53, **54**, **55**
9940	57, **58**
9995	63, **64**
9999	58, **59**
10009	51, **52**
10016	60, **61**
10018	62, **63**
10184	**46**
10265	69
10470	7, **18**, 55, **56**, 57
10471	52, **53**
10472	57, **59**
10479	63
10541	62
10554	7, 47, **48**, **49**
10558	7, **49**, **50**
10793	61
12784	11
24906	70
26706	45
27332	67
30841	**68**
37976	30, **31**
37977	26, **27**
37978	30, **31**
37980	**32**
37981	29
37982	32, **33**
37983	29, **30**
37984	28, **29**
37986	**28**
37987	26
37991	**23**
37993	35, **36**
37994	35
37995	35, **36**
43215	**69**
43465	16, **17**, 23
43467	22, **23**
43480	45
45217	10
50710	**45**
52947	7
55617	39
58212	19
58830	37
58832	**38**
58846	38, **39**
64395	45
68539	45
69014	19
69015	19, **20**

Index

Abydos 9
Afghanistan 12
Africa 24, 26
Ahmes-Nefertari 35
Akhenaten 6, 37, 41, 42
Alexander 50
El-Amarna 17, 37–41, 51
Amenophis I 35, 36
Amenophis II 42, 43, 51
Amenophis III 26, 41, 51
Amenophis IV 41
Amon-Re 5, 67
Amosis 11
Amun 30, 35, 57, 61, 62
Anhai 57–59
Ankhwahibre 7, 49, 50, 62
Anubis 42, 50, 54, 64, 66

baboon 20, 21, 46, 50, 52, 62
Bak 6
banquet 28
beeswax 12
Beni Hasan 20, 21
blow-pipe 26
Book of Breathings 62
Book of the Dead 18, 47–50, 51ff, 68, 69
Book of what is in the Underworld 62

Cairo 23
Cairo Museum 20
canon 16
carbon 11
caricature 44, 45, 60
cartonnage 70
cartoon 9
cattle 30, 31
chariot 32
coffin 68, 70
conventions 5, 7, 16, 17, 21, 29, 34, 35, 44, 65

Davies, Nina de G. 7, 13, 20, 21, 37
Davies, Norman de G. 10, 37
Deir el-Bahri 5, 69
Deir el-Bersha 21, 65, 68
Deir el-Medina 33–35, 44, 60, 66
Deniu-en-Khons 67
Djefu 66
Djehutihotpe 65, 67

Egyptian blue 11, 23

Faiyum 23, 64
Faulkner, R.O. 51
Field of Reeds 53, 63
fresco 11, 12, 38, 39
funeral 55

garden 29
Geb 48
geese 30–32, 60, 61

gesso 13, 16, 37, 39, 67
gold-leaf 57, 58
gouache 12
Great Harris Papyrus 58
Greece 50, 64
Greenfield Papyrus 47, 49
Green Room 37, 38
grid 11, 13, 17, 40, 41
guidelines 13, 40, 44
gum 12
gypsum 11, 13, 19

Hathor 18, 64, 69
Heliopolis 58, 59
Henttowy 62, 63
Herihor 62
Herunefer 53
Hetepheres 65
Hierakonpolis 19
Hor 69
Hori 63
Horus 50, 54, 63, 64
Hunefer 53–55

Ikhekhi 9
Inherkhau 34, 35
Isis 55
Itet 7, 19, 20, 21

jewellers 25
judgement 50, 53–56, 62
juncus maritimus 10

Karnak 42, 43
Katep 65
Kerasher 63, 64
Khaemwese 13–15, 17
khekher 26
Khentika 9, 10
Khnumhotpe 20, 21
Kynebu 35, 36

lamp 18
lapis-lazuli 12
Libyans 42
line drawing 40ff
linen 68–70
Louvre 62

Maat 50, 52, 53, 62
Maidum 7, 19, 20
Maidum Geese 20, 21
malachite 12
Mariette, A. 20
Maruaten 38, 39
Medinet Habu 43
Mehet-weret 47
Memphis 58
Mentuhirkhopshef 11
Mereruka 10, 40, 41
metal-workers 25
Munich 62
murals 19ff

Nakhte 52, 53
Natron 12

Nebamun 7, 26–33, 37, 53, 60
Nebre 8
Nebseny 47
Nefermaat 7, 19–21
Neferronpet 57, 58
Nefertiti 42
Nephthys 55
Nesha 54
Nesitanebtashru 7, 47, 49, 61
Nodjmet 62
Northern Palace 37
Nubia 24
Nubians 42
Nut 48, 49, 53

orpiment 12
Oryx Nome 21
Osiris 8, 35–37, 50, 52–56, 61, 64, 66
ostraca 43–46, 60
outline scribe 6, 8, 9, 37, 40, 43, 47

palette 8–12, 31, 40, 55, 63
papyrus 31, 46–50, 51ff, 65, 69
Pasenhor 70
pattern books 9
Penbuy 66
Persia 12
Pes-shu-per 6
Petrie, Flinders 20
pigments 11f, 20, 39, 55
Pinudjem I 47
Pinudjem II 61
Place of Truth 34
pool 29, 53
proportions 13
Ptah 66
Ptahshepses 66

Ramesses II 9, 65
Ramesses III 43, 58, 59
Ramesses IV 8
Ramesses VIII 35
Ramesses IX 43
Ramose 40–42
Re 52, 53
Re-Harakhty 59, 63
red ochre 11
relief 6, 8, 9, 21, 40, 62

Saqqara 9, 19, 40, 41
Satirical Papyrus 60
scribe 8, 31, 40
sculptor 9
senet 56, 57, 60
Seni 68
Shu 48
size 12, 67
Snofru 19
Sobk 10
Sobkhotpe 23–26
Sobkhotpe, stela of 66
Sons of Horus 35, 56
Syrians 23, 26, 42

taper 18
tax-assessment 32, 33
tempera 6, 11, 12, 40
Theban Necropolis 9, 13, 22, 26, 34, 41
Thebes 7, 10, 11, 14, 16, 22, 23, 30, 32, 33, 37, 40–42, 45, 58, 60, 61
Thoth 9, 52, 54, 62, 64
Tjuiu 52, 53
Turin Museum 8
Tuthmosis III 16
Tuthmosis IV 23
Tutu 56, 57, 60

Userhat 51

Valley of the Kings 33, 34, 42
varnish 12
Victoria and Albert Museum 19

Wain, Louis 60
We'eb 34
whiting 12

yellow ochre 12

Photo acknowledgements

The photographs used in figs 7 and 9 are reproduced by kind permission of the Egypt Exploration Society. Those in figs 1, 2, 6, 20, 33, 42–45 are the copyright of T.G.H. James. All other photographs have been provided by the Photographic Service of the British Museum, and the work of Peter Hayman is particularly acknowledged.